Practical
Symbols

✳

Runes and Sigils for
Holistic Wellbeing

Practical Symbols

Amy Donnelly

Illustrated by
Viki Lester

♦♦♦

Leaping Hare Press

Contents

Introduction 6
Context 8
Symbol Use in Witchcraft 9
The Changing Nature of Symbols 10
Choosing Symbols 12
How to Use Symbols 14
Sources of Symbols 15

Chapter 1: Symbols for Wellness 24
Chapter 2: Symbols for Physical Wellness 52
Chapter 3: Symbols for the Sabbats 66
Chapter 4: Symbols for the Moon 84
Chapter 5: Symbols for Special Occasions 94
Chapter 6: Symbols for Careers 112
Chapter 7: Practical Sigils 122

Conclusion 134
Recommended Reading 135
Index of Symbols 136
Acknowledgments & About the Author and Illustrator 140
Index 141

Introduction

I have long been passionate about history and folklore. As a child, my life was peppered with folk traditions learned from my east London family—throwing salt over our shoulders, crushing eggshells to stop witches riding on them, putting a pin in a cushion to help find a lost item—and I found it fascinating that we carried on these practices. It felt like there was magic in these actions, passed on through generations until they became an everyday ritual.

Growing up in London, I was also lucky enough to have access to wonderful museums and galleries as well as incredibly supportive parents who fostered my love for the past. The everyday aspects of history amazed me the most. The physical objects and stories created and passed on by the general population held more appeal than the written accounts of those who held power. I wanted to know how people lived, what they felt, and how those things were impacted by their personal experiences. I studied archaeology at university, focusing on early medieval Britain, and became enthralled by the material culture of everyday life.

It was only after I graduated that I began to focus on the connection between folk traditions and archaeology. The physical remnants of history told us how people lived, but folklore and tradition told us what they believed and how they made sense of the world around them. I later completed a postgraduate degree in anthropology and archaeology, focusing on the impact of experiences of conflict on perceptions of the past. I was lucky enough to spend several seasons of fieldwork in rural southern Albania, learning the folk traditions and stories of the Kurvelesh region.

Pentagram

Aquarius

I have always wanted to publish a book and being able to combine my passions of history and Witchcraft has been a dream come true.

This book is about how you can use magical symbols in your practice and everyday life. It includes the historical background for a number of the symbols, providing information on their importance and power, and practical ways to incorporate them into your life on a daily basis.

My love for folklore mixed with my practice of Witchcraft. I researched folk traditions, incorporated them into my craft, and used symbols I uncovered along the way in my rituals. I also began to incorporate images from my experiences of archaeology into my practice. These symbols had rich histories and, by learning about them and the people who used them before, I found I could truly understand the power they held.

Þjófastafur

Introduction

Context

The symbols in this book are gathered from a wide variety of sources: from Elder Futhark runes used in the 1st to 8th centuries and images uncovered from Pictish archaeological sites, to alchemical symbols and Neopagan glyphs created in the last decade. Each has its own history and holds its own unique power.

Magical symbols are not just found in history. Any symbol can be made magical when imbued with intention and belief. A lack of history does not make a symbol less useful or powerful, but understanding its past can provide us with a deeper understanding and respect when using it in our own practice.

Symbols can be found anywhere, and we are the ones who imbue them with magic and power by discovering their history and instilling them with intention. As practitioners of magic and Witchcraft, we weave together our ideas, beliefs, and energy with the historical power of symbols to create deeper meaning in our rituals and practices.

Ostara

Wunjo

Pictish Sun Disk

Symbol Use in Witchcraft

Symbols and sigils have long played an important role in magical practice. They are used to represent beliefs and ideas, deities and seasons, and experiences and emotions. Throughout the world, symbolic images such as runes and sigils have been used and repeated for centuries, and remain prominent in Witchcraft.

The term occult comes from *occultus*, the Latin word for "hidden." Historically—and unfortunately, still to this day in some places—those who practiced magic were at risk of persecution or harm from others, and many wished for their craft to remain unseen. Magical symbols were shrouded in mystery to protect the practitioner and stop the wrong person from recognizing them. Some also held a belief that magic lost some of its power when shared, a view that some still maintain.

Modern Witchcraft is full of deeper meanings and we use symbols in a wide range of ways. Each card in a tarot deck has distinctive imagery that provides a narrative, the colors we choose for candles and altar decorations correspond to specific deities or intentions, and even the plants and herbs we use have been chosen due to their symbolism. For example, lavender for peace, bay leaf for protection, and nutmeg for prosperity. We gather information about these correspondences from books, the internet, and by sharing our experiences and practices with others in the community.

However, symbols are also deeply personal. What may seem like a simple image of a leaf or a pattern of lines may have a deeper meaning to the creator. Those personal interpretations and the intentions held while choosing it are what give a symbol its power.

But how do we know which symbols are best suited to our needs and how can we incorporate them into our daily life?

The Changing Nature of Symbols

The correspondence of symbols—for example, the emotions, seasons, and situations they relate to—can help in deciding which to use in our practice. Some seem pretty straightforward, such as the Neopagan symbol for Mabon or a four-leaf clover. However, for other symbols, knowing their history and how they have been used in the past can alter how we view them today.

Think of an object or place that's special to you. A mug gifted by a close friend, a necklace that belonged to your grandmother, the place where you met your partner. Before you came into contact with them they already held a history of their own, but your experiences and feelings now attached to them have morphed these objects or places into something deeply personal. You have changed their context, and altered their path. The same happens with symbols.

An example of this can be seen with the use of the Elder Futhark rune, Dagaz. In magical correspondence, we often associate Dagaz with growth, revelation, and clarity. However, learning the history of the rune can widen our understanding of it.

Originally, Dagaz was formed for use in the Elder Futhark alphabet and has been used to communicate and record. It was also used to represent the word "day." Dagaz was also used in northern Europe in the 17th century as an apotropaic mark—an evil-dispelling symbol for protection—and was carved into buildings to protect against evil spirits and witches. It has also been found in caves used for storage, since it was believed to bring light to dark places. What started as a letter in an alphabet has morphed and changed based on the beliefs and use of humans throughout history.

Dagaz

Mabon

Learning the history of a symbol can provide a wider understanding of how it came to be, and can also assist in helping us appreciate its power, built up over centuries of use and devotion.

Unfortunately, this can work in the opposite direction. Symbols have been used to represent both good and evil throughout history, changing how we see and interact with them. A good example is the solar cross. Found in numerous Bronze Age archaeological sites, it is believed to represent Sun worship. However, in the 20th century, the symbol was coopted by white supremacist and Neo-Nazi groups, dramatically altering its interpretation.

Magical symbols are empowered by centuries of use and belief, both positive and negative. While I believe our intentions and personal interpretation are important when choosing which to work with, the negative history associated with a symbol—such as its role in the oppression of others—and the impact it has on others should not be overlooked.

Choosing Symbols

The use of symbols in magic is a multifaceted practice. It brings historical power to our work, is a creative experience, and draws on generally accepted and personal interpretations of the symbols.

While many symbols are related to a specific meaning—for example, astrological symbols have direct links to specific star signs—some have more obscure correspondences that can be uncovered through research. For example, Algiz, the fifteenth rune in the Elder Futhark alphabet, directly translates as "elk." However, it is the rune of protection and the higher self in divination. Many symbols have layers of interpretation to uncover.

There are limitations to our understanding of magical symbols. It is impossible to know what every symbol represented when used in the past, since some interpretations or uses will have been lost to time. We can make educated guesses, based on historical and archaeological contexts, to develop a modern spiritual, magical practice that is fulfilling and authentic to what we do know. However, using our own intuition and belief can add a personal element to the symbol.

Research

Recognizing and respecting the life story of a symbol allows us to draw on its potent magic—intensified by hundreds of years of use—and adapt it to the needs of today.

There is a wealth of information available online and in books when researching the history and correspondences of magical symbols. Being able to assess and evaluate sources for reliability is a skill within itself, which is well worth developing—both in your magical practice, and in everyday life.

Algiz

When researching the history of a symbol, consider the following:

1. Has the author provided any sources of information?
2. Are the sources reliable—is it based on evidence?
3. Can you find other examples of their interpretation?
4. Does it make sense to you, based on what you already know?

If your answer is "no" to any of the above, it is worth continuing with your research until you are more confident in the answer.

Having a well-researched background of magical symbols—their origins, how they were developed, the ways they were used in daily lives, and information about the people who used them—means you can make informed choices about the symbols you use in your own practice.

I encourage you to do your own research on magical symbols—including those in this book—to further your understanding and appreciation.

Using your intuition

While knowing the historical and cultural context of a symbol is important in understanding its power, using your own intuition is equally vital.

Witchcraft is built on the experiences and interpretations of thousands of past practitioners. However, it is also deeply personal. As magical practitioners, we choose which images and aspects of our lives to highlight and bring into the world, and the symbols we choose to use are a reflection of that. What may seem like a simple image to others may have a deeper symbolic meaning to us.

If you feel drawn to a particular symbol or icon, consider why. It could be familiar to you, it may belong to a culture or society you are interested in, or it could just be aesthetically pleasing. Whatever the reason, what matters is that your chosen symbol is filled with meaning and intention.

How to Use Symbols

There is a multitude of ways to incorporate symbols into your magical practice. They can be used throughout everyday life in the following ways:

- In place of an item—for example, using a symbol for wine in place of a glass
- Carved into candles
- Drawn on mirrors or windows with wax or paint
- In prominent areas of the home, such as entrances and thresholds
- Embroidered into clothing or bedding
- Drawn onto your skin
- Used in artwork
- Painted on your nails
- Traced in water
- Outlined in soil
- Drawn in the air with incense
- Carried with you during work, for example behind your ID card or phone case
- Incorporated into journaling or shadow work
- Drawn in oil while cooking
- On your phone background

Sol

Stan

Sources of Symbols

Magical symbols can be found anywhere. The symbols in this book have been sourced from a wide range of places. Some, such as the pentacle and triskele, will be familiar to magical practitioners and have long associations with Witchcraft. Others have been found in nature, alchemy, mythology, and astrology. A number, such as Pictish symbols and engravings from early medieval artefacts, have been gathered from my own experiences in archaeology and anthropology.

There are limitations to the symbols covered. I have only included those I hold a connection with or feel a relation to. If you would like more information on magical symbols from areas not covered by this book, several sources are listed in the Recommended Reading section on p135.

Cauldron

Luis

Elder Futhark

Also known as the Older Futhark or Germanic Futhark, the Elder Futhark (Fuþark), is believed to be the oldest runic alphabet in existence. A writing system of the Germanic people, it was in use from the 2nd century CE to the 10th century. The Elder Futhark consists of twenty-four runes, which were used as a form of writing. However, each rune also symbolizes a specific meaning such as a deity, event, or aspect of the environment.

Runestones featuring Elder Futhark inscriptions have been uncovered throughout Scandinavia and southeastern Europe. For example, the Svingerud runestone from the 2nd century and the Kalleby runestone dated to the 5th century. Other artifacts, such as amulets, belt buckles, and carved bones, have also been unearthed.

Berkana/ Bjarka

Isa

Mannaz

Ear

Ing

Modig

Anglo-Frisian

Anglo-Frisian runes have origins in the Elder Futhark alphabet. Originating in Friesland, in what is now northwest Germany, they were brought to England and Scotland by Saxon migrants. Anglo-Frisian runes were in daily use from the 5th century CE to the 10th century, and examples survive from this period, mainly in Christian inscriptions. Some Pagan examples also exist. Although the original alphabet consisted of twenty-eight runes, a further eight runes have been recognized as later additions due to the frequency of their use in manuscripts and artifacts from the 9th and 10th centuries.

Artifacts bearing runic inscriptions have been uncovered throughout England and Scotland, such as the Seax of Beagnoth, a knife dating to the late 9th century that was found in the mud of the Thames in London; the Franks Casket from the 8th century CE, a decorative box displaying Christian imagery and Germanic legends; and the 8th-century Ruthwell Cross, a 5.5-metre tall stone cross engraved with Old English poetry, found in Scotland.

Ogham

Ogham is an alphabet primarily used to write the early Irish language. The earliest surviving inscriptions date from the 4th century CE, although some historians believe it originates as early as the 1st century BCE. The original Ogham alphabet consists of twenty characters, known as *fedas*, arranged into four groups. Five additional *fedas*, called the *forfeda*, were introduced later.

There are multiple interpretations of Ogham letters based on the names of trees or shrubs—known as the arboreal tradition—or through the medieval kennings named Bríatharogaim. Three sets of kennings survive, which explain the meanings of the names of the Ogham letters: Bríatharogam Morainn mac Moín, Bríatharogam Maic ind Óc, and Bríatharogam Con Culainn.

Beith

Oir

Ifín/Pín

Sources of Symbols

Brýnslustafir

Draumstafir

Icelandic Staves

Icelandic staves are sigils believed to hold magical powers. They were created to assist with everyday issues such as preventing barrels from leaking, finding out who stole your butter, and warding off animals. However, a number of staves related to Witchcraft also exist. The vast majority have been preserved in grimoires—books recording magical practices—from the 17th century onward.

Due to the popularity of Icelandic staves, many variations appear online or in books, some of which are not historically accurate. Many of the original grimoires that feature staves are available to view online on the website handrit.is, which holds over 20,000 manuscripts from Icelandic history.

Lukkustafir

Sources of Symbols ♦♦♦ 19

Pictish

The Picts were a group of people from northern Britain. The culture, which reached its peak between the 5th and 10th centuries CE, has left a lasting mark throughout the landscape in the form of standing stones. Archaeological records suggests Picts were largely farmers, growing crops and keeping animals in large numbers, although earlier generations are recorded as raiding the coasts of Roman Britain by boat.

Pictish art includes metalwork such as decorative brooches and weapons, but the majority of surviving examples are found on monumental stones and stelae, predominately situated along the north-eastern coast of modern-day Scotland. These stones depict carvings in a Celtic style—a term used to describe groups from Europe and west Asia who shared similar languages and art styles.

Due to limited recorded history and the weathering of stones, it is difficult to understand the meaning of the symbols, although historians and archaeologists have interpreted some based on other Celtic cultures and the context of the surrounding landscape.

Crescent and Arrow

Pictish Serpent and Spear

Pictish Sun Disk

Honey

Wheat

Wine

Linear B

Linear B is the oldest example of the Greek language, dating to around 1400 BCE. Adapted from Linear A—an as yet undeciphered script—it was used by the Mycenaean Greeks, and examples have been uncovered in the archives of the Bronze Age palaces of Knossos and Mycenae. Consisting of almost two hundred ideograms or symbols that represent an idea or concept, archaeologists believe they were limited to use in administrative concepts such as recording wares or selling animals.

While most symbols in Linear B have been deciphered, the meaning of some remain unknown.

Sources of Symbols

Any symbol can be made magical when imbued with intention and belief

Symbols for Wellness

Symbols for Confidence

- Sol
- Leo
- Bird
- Luis
- Modig
- Tetrahedron

◊ **Leo**, an astrological star sign ruled by the Sun, represents a natural born leader who can inspire others through their confidence and ability to take charge. When you need to bolster yourself as a leader, or when working with others, carry the symbol of Leo on you to imbue yourself with this sign's confidence.

◊ **Sol**, the sixteenth rune in the Elder Futhark alphabet, represents victory, achievements, and positive outcomes. It can be difficult to feel confident in your actions when the future is uncertain. In these moments, picture the Sol rune in place of your goal, using it as a stand-in when uncertain about the outcome. Even if the future seems cloudy, have faith that you will be victorious.

◊ **Birds**, during the early medieval period, were emblems of victory and believed to converse with deities. This specific bird symbol comes from an artifact found within the Staffordshire Hoard, a collection of almost 4,600 items and fragments uncovered in England that date to approximately 650 CE. It is the largest collection of early medieval gold and silver excavated in one place. All of the items are of high-quality craftwork and likely belonged to someone of power and authority. Confidence can be difficult to summon if you cannot see it in yourself. Draw this bird emblem on a piece of paper while thinking of those you know who ooze confidence—whether it's a friend, public figure, or member of early medieval nobility. Carry the symbol with you when you need to channel their assertive power.

◊ **Luis** is the second letter in the Ogham alphabet and gets its name from the Old Gaelic words used for "shine" and "grow." To boost your confidence, carve the Luis symbol on a yellow candle and burn it while completing the task or activity you feel you need confidence for. As the candle burns and the light shines bright, feel your confidence grow.

◊ **Modig** is an Anglo-Frisian combination rune, carved into the 8th-century Ruthwell Cross in Ruthwell, Scotland. The large stone cross features a runic poem, which includes the Modig, a rune that represents courage and pride. Pride is often viewed in a negative light but feeling pride in yourself, and the work you have done, is a powerful feeling that can spur you on during difficult times. When you are lacking in confidence, meditate on the Modig rune and think of all the successes you have achieved, however small. Use that feeling of pride to drive you going forward, lighting a fire under you to succeed once again.

◊ **Tetrahedron** symbols in sacred geometry represent the element of fire, reflecting its dynamic and transformational nature. The tetrahedron helps you to visualize the balance of heat, oxygen, and fuel needed to create the sparks of fire. Focus on the tetrahedron and consider what elements you need to ignite the spark of confidence in you. Do you need support, or perhaps a reminder of what you can achieve? Do you feel stressed and need time to rest and relax? Find your balance and feel your confidence light up.

Symbols for Joy

Uilleann

Wunjo

Marian Mark

Pentagram

Iris

Daisy

◇ **Uilleann** is one of the *forfeda*, or additional letters of the Ogham alphabet, representing honeysuckle. Honeysuckle creeps and climbs its way toward the light, growing over time to cover large areas and spreading joy with its brightly colored and sweetly scented flowers. Trace this symbol in bath water infused with honeysuckle oil when you seek joy. As your body is submerged in the blissful scent, be inspired by Uilleann and allow yourself the freedom to grow toward your dreams, spreading out and taking up the space you deserve.

◇ **Wunjo**, the eighth rune of the Elder Futhark alphabet, translates as "joy." It is a signifier of cheerful times, new beginnings, and the possibility of happiness. Wunjo can also be used in magical practice to remove energy blocks to joy. Carry Wunjo with you to ward off negativity and invite joyous energy into your life.

◇ **Marian Marks** are apotropaic symbols used between the 16th and 18th centuries in Europe to protect buildings from evil energies. Often found near liminal spaces such as fireplaces, on beams, and above doors, they gained their name from the Virgin Mary. As envy is often the thief of joy, use Marian Marks to protect yourself against negative energies and jealousy from others. Place this symbol near the entrances to your home or where you work, to protect your joy.

◇ **Pentagrams** are a common symbol in Witchcraft. They represent the five elements—water, air, earth, fire, and the soul—working together in perfect balance. Pentagrams inspire you to look at all aspects of your life and assess if everything is in balance. If it isn't, consider what you can do to work toward a more balanced, joyful life. Pentagrams are also apotropaic symbols that offer protection against negative energy. Wear a pentagram near your heart to protect your joy but also to remind yourself that imbalance in your life can hinder you from experiencing joy.

◇ **Iris** is the Greek goddess of the rainbow and messenger of the gods. Daily stress and the uncertainty of life can prevent you from feeling joy, but rainbows cannot exist without both sunshine and rain. Iris's symbol is a reminder that happiness and sadness can co-exist, and to appreciate the small joys among the storms. Draw or trace this symbol on a window in your home; as the Sun shines through, it will charge your room with Iris' joyful energy.

◇ **Daisies** represent purity, innocence, and joy. They are a reminder of the beauty that can be found in simplicity. Daisies can be found growing through the cracks in concrete and alongside busy roads, proving that joy and beauty are possible in even the most challenging situations. Place daisies—flowers or a drawing—in a place you see regularly to remind yourself that joy can be found in even the darkest times.

Symbols for Productivity

- Brýnslustafir
- Ehwaz
- Victoria
- Cancer
- Metis
- Bull

◊ **Ehwaz**, the nineteenth rune in the Elder Futhark alphabet, symbolizes progress. Its literal translation of "horse" represents an onward journey, forging ahead through difficult situations and terrains. Horses are wild and powerful, but can be tamed through hard work, persistence, and respect. You may feel the passion and drive to begin a task but it is only through perseverance that it can be completed. Focus on Ehwaz when you are struggling with productivity, keeping the symbol in view as you work, to help you stay on track.

◊ **Brýnslustafir** is a magical Icelandic stave carved on whetstones from the 17th century onward. It was believed to magically aid in the sharpening of knives and blades. Paint Brýnslustafir on a stone, evoking its original use on whetstones, and carry it with you to help sharpen your mind and focus your thoughts on the task ahead.

◊ **Victoria** is the Roman goddess of victory. She was celebrated in the Roman Empire not only as the personification of success, but as a symbol of triumph and the subsequent peace following a conflict. Draw this symbol on paper and burn it with loose incense made from rosemary and common sage to fill your space with the scent of victory, triumph, and productivity.

◊ **Cancer** is an astrological star sign that represents a highly intuitive, imaginative, and tenacious individual. However, Cancers are also drawn to comfort and self-care. If you are struggling to be productive, ask yourself if there is something holding you back. Are your needs met? Make sure to care for yourself so you are in the best position to be productive and actively working toward your goals, rather than wearing yourself thin in the process. Carve Cancer's symbol on a candle in a calming pastel color and burn it while actively caring for your own wellbeing, such as when reading your favorite book or taking a long, restful bath.

◊ **Metis** is a Greek goddess and the first deity in the Greek pantheon praised for her wisdom and cunning. She has the ability to shapeshift, and was celebrated for her magical abilities. Honor Metis's wisdom and shapeshifting abilities by placing this symbol at your altar to inspire you to stay level-headed and focused, and to be flexible when the task requires it.

◊ **Bulls** are determined and strong, and often unstoppable when they have their sights set on a goal. Although they are often used to symbolize highly charged emotions and unbridled chaos, they are also incredibly strong-willed and focused animals. Draw the bull's symbol onto the bottom of your shoes, ensuring that every step you take channels the bull's determined energy as you forge ahead toward your goal, regardless of how life tries to distract you.

Symbols for Positivity

- Dagaz
- Sunflower
- nGéadal
- Pentacle
- Vessel
- Sun

◊ **Sunflower** symbols radiate positivity and hope. As they grow, sunflowers will turn toward the Sun in their quest for light and warmth. Dried sunflower petals can be used in loose incense to spread the scent of positivity throughout your space. Once cooled, use the ashes to draw a sunflower on paper and display it in a place you see every day to remind you to seek out light and stand tall in the face of hardship.

◊ **Dagaz**, the twenty-third rune of the Elder Futhark alphabet, translates as "day." Dagaz is a powerful rune of change. It is a reminder that light can triumph even in the darkest times. Dagaz's use as a representation of light continued through to the 17th century, primarily as an apotropaic symbol to protect places and people against dark spirits. Wear Dagaz—embroidered onto your clothes, on jewelry, or drawn on a piece of paper slipped into your phone case—to shine light into your life.

◊ **nGéadal** is the thirteenth letter of the Ogham alphabet. It is interpreted as representing the fern plant, which was believed in medieval Britain to protect dwellings and dispel negativity. When the world seems dark and the future uncertain, it can be difficult to keep sight of the good. While reacting negatively to hardship is a natural response, finding the positive can help to drive you forward and act. Place a fern in your home, or draw one by the entrances to your home, to dispel negativity and allow you to see the good amongst the bad.

◊ **Pentacles** are apotropaic symbols often found in magical practice, used to attract positive energy and drive away the bad. Their use as an apotropaic symbol is steeped in history. In the medieval period, Christian belief held that pentacles were a powerful repellent of malevolent spirits. Wear this powerful symbol to drive away the dark and bring light and positivity into your life.

◊ **Vessels** have long represented the human body and are an important symbol in spirituality. They are a reminder that you hold a multitude of thoughts, feelings, and energy within yourself. While you may want to assist others and spread positivity, it is not possible to pour from an empty cup. Use this symbol—representing vessels in the ancient Mycenaean Linear B alphabet—in journaling and shadow work, as a prompt for meditating on your wants and needs, and when taking steps to ensure your wants and needs are fulfilled.

◊ The **Sun** is a powerful symbol. For centuries, cultures have revered the Sun and its power, celebrating its life-giving force and warmth. Outside of spirituality, it is believed that exposure to sunlight increases serotonin—a hormone associated with boosting mood—in the brain. Its consistent and reliable cycle is a reminder that no matter how dark the world may seem, the Sun will always rise. Imagine the Sun shining through you, overflowing with warmth and joy, and let the light and positivity shine through you and your actions.

Ailm

Lásabrjótur

Kenaz

Symbols for Focus

Owl

Gungnir

Waxing Gibbous Moon

◊ **Kenaz**, the eighth rune in the Elder Futhark alphabet, represents guidance, revelation, and knowledge. It also directly translates as "torch." Negative thoughts can distract you and make it difficult to stay motivated. Place this symbol, alongside crystals for focus such as fluorite, Iolite, and hematite, near you to help shine light into your thoughts, banishing the negativity and guiding you in your work.

◊ **Ailm** is the sixteenth letter of the Ogham alphabet and is believed to represent the pine tree. Pine wood is often used for Yule logs, which are lit to burn bright for several weeks during the winter season. In the Bríatharogam—a kenning, or figurative play on words, that explains the meaning of the Ogham—Ailm was also associated with the beginning of an answer. Carve Ailm into a blue or yellow candle and burn it near your workspace to spread light and help you see clearly as you focus on the beginning of your answer.

◊ **Lásabrjótur** is one of the Icelandic staves and was used as a charm to help open a lock without a key. When struggling to focus it can often feel like what you need is just out of reach, locked behind a door or wall that you cannot break through. Focusing on this symbol, imagine a door ahead of you unlocking and opening. Take a deep breath and step through. Lásabrjótur can help you to break down barriers and find clarity when the way forward feels beyond your reach.

◊ **Owls** have been considered a symbol of wisdom throughout humanity. Athena, the ancient Greek goddess of wisdom, had an owl as her symbol, and in Sumerian mythology, Lillian, the goddess of death, was flanked by omniscient owls. This symbol, featured on a harness mount excavated in south Gloucestershire in England, dates from the Iron Age. Harness the powerful energy of the owl, accumulated over thousands of years of reverence, and channel its wisdom whenever you find your mind wandering from your task.

◊ **Gungnir** is Odin's spear in Norse mythology, and is known for its speed and accuracy. Distractions can easily lead you astray from your goals and make it hard to remain focused. Draw this symbol next to a list of your goals to help keep your mind sharp, identify your aims, and meet your target.

◊ The **Waxing Gibbous Moon** phase is a time of improvement and preparation, when the Moon is almost at its fullest. This phase and symbol encourages you to look at your progress and make any adjustments as you continue on the path to your goals. Assess where you are and what you need to focus on to achiev your goals. How can you improve your current mindset? What is holding you back from progress? What can you do to prepare and make sure you are in the best possible place to focus?

Symbols for Protection

- Snake
- Algiz
- Uath
- Widdershins
- Nazar
- Auseklis Cross

◇ **Algiz** is the fifteenth rune in the Elder Futhark alphabet and directly translates as "elk." However, in runic divination, Algiz is seen as the rune of protection and the higher self. This symbol can be used to protect both your physical and spiritual self, defending you against negative energy. Embroider Algiz into your clothing in the protective colors of black or white; this will absorb or deflect the harmful intentions of others.

◇ **Snakes** represent luck, transformation, rebirth, and protection. This pattern, found adorning a gold sword hilt in the 7th-century Staffordshire Hoard excavated in England, shows two snakes intertwined. The snakes offer an impenetrable defensive wall against an attacker, protecting the wearer against harm. Use this pattern to decorate everyday items you regularly carry with you to repel negative energies that seek to cause you harm.

◇ **Uath**, the sixth letter of the Ogham alphabet, has several translations: "the whitethorn tree," "horror and fear," and "most difficult at night." Whitethorn trees, also known as hawthorn, are steeped in Irish legend and folklore. Magically, hawthorn symbolizes protection, love, and hope and was believed to be a gateway between the human and Fae worlds. Place this symbol outside your front door to offer protection for the home, but do you not bring hawthorn into your home because it can bring bad luck to those who dwell within.

◇ **Widdershins** is the word used to describe the opposite direction to the Sun's course, or counterclockwise. It is used in magical practice when casting binding or banishing spells and charms. Stir the Widdershins symbol in your daily cup of tea or coffee as a way of reflecting negative or harmful energy back to its source, protecting yourself, and allowing those with evil intentions to experience the negative impact of their actions.

◇ The **Nazar** is an amulet used to protect against the evil eye. It can be found throughout multiple folk traditions under several names in Asia, the Balkans, and the Mediterranean. The evil eye is a curse brought about by a malevolent or jealous look, and the Nazar acts to distract and repel the curse back on those who wish to cause harm. Nazar amulets can be commonly found in stores and should be displayed outside the home or on your person to distract jealous or harmful gazes.

◇ The **Auseklis Cross** is an apotropaic symbol from the 15th century onward, and was commonly found carved into buildings in eastern Europe and Britain as a form of protection. It is largely seen as representing a star, bringing light to banish the darkness. Carry the Auseklis Cross with you on dark days to protect yourself from negative feelings that can damage your self-worth. It will banish the harmful thoughts by shining light on the parts of yourself that bring you confidence and joy.

Symbols for Love

Claddagh Ring

Venus

Wishbone

Muin

Infinity

Bow and Arrow

◊ **Venus** is the Roman goddess of love, beauty, and desire. Her festival in the spring was celebrated with wine, vegetables, and flowers. Venus is a reminder of the beauty of the natural world and the importance of celebrating it with an open and full heart. When love is blooming in your heart, fill your altar or a space with flowers and place this symbol in the middle to honor Venus and the innate beauty of nature.

◊ **Claddagh Rings** are traditional Irish rings that were often used for engagements or weddings. The symbol features a heart for love, a crown for loyalty, and two clasped hands for friendship. The Claddagh symbolizes three important aspects of romantic and platonic love—a heart to represent love, a crown for loyalty, and clasped hands for friendship—and acts as a reminder of their importance when cultivating a lasting and true relationship. Gift a Claddagh ring, or an item bearing the emblem, to a lover as a promise to not lose sight of these foundations of love.

◊ **Wishbones** are a symbol of good luck and fortune. When a wishbone is broken the person who holds the larger piece is believed to have their wish granted. However, a full wishbone symbolizes the *potential* for wishes to be granted and, when gifted to another, is an acknowledgment that the recipient has a wish you hope will come true for them. If you feel you have lost hope in love, keep hold of an unbroken wishbone. You can also sew the wishbone symbol into your pillowcase to attract good luck and fortune.

◊ **Muin**, the eleventh letter of the Ogham alphabet, can be interpreted as representing love and esteem. It motivates you to look toward yourself and consider the love you show yourself before you reveal your heart to others. Muin offers protection through boosting your self-esteem. Guided by Muin, write a list of the aspects of yourself you love and adore, keeping it close to your heart as a reminder when your esteem is low.

◊ **Infinity** symbols are instantly recognizable. Although their use dates back to the Viking era, they were made popular in the 17th century by the English mathematician John Wallis to represent the concept of perpetual infinity. Their use has now grown beyond scientific application and they represent eternal love, and the unbound power of love and adoration. If you seek infinite love, embroider this symbol on a pouch in pink or red thread and fill it with pink quartz, malachite, and garnet. Hold the pouch by your heart and imbue it with your intentions, speaking what you seek into the universe.

◊ The **Bow and Arrow** is a symbol of Cupid, the Roman god of erotic love and desire. It represents the unpredictable nature of attraction and is a reminder that love can both harm and heal you. Use this symbol alongside symbols for sexual energy (see pages 62–3) to attract love, or draw it on paper and burn it with loose incense made of rosemary, bay leaf, and basil to break a connection you no longer wish to hold.

Symbols for Gratitude

Semargl

Fractal

Wheat

Ceirt

Mannaz

Stan

◊ **Fractals** are shapes in sacred geometry that are created using a consistent ratio and repetitive pattern. They signify the small things that work together to create a whole and represent the building blocks of the universe. It can be difficult to be grateful for the small things, particularly when facing adverse or difficult circumstances. Draw a fractal and write the things, however small, you are grateful for in your life within the shapes, watching as they gradually build to create a body of joy and hope.

◊ **Semargl** is an East Slavic Pagan god of fire and the Sun. A benevolent deity, Semargl holds great strength and wisdom, bringing light and warmth to the world. When faced with inner turmoil, carry this symbol with you to bring light to your life, chasing away the dark, negative energies that cause fear and self-doubt, and leaving behind only the warmth of peace.

◊ **Wheat** represents bounty and abundance, and the generosity of nature. Since the Industrial Revolution, humans have largely moved away from their connection with nature. However, our impact on nature has increased, leading to often devastating effects. The symbol of wheat is a reminder of the connections between humanity and nature, and the bounty nature continues to provide in the face of widespread destruction and ruin. Be inspired by this symbol to reconnect with the landscape and show gratitude for the abundance it provides, taking steps to lessen your own negative impact going forward.

◊ **Ceirt**, the tenth letter in the Ogham alphabet, has two translations: "apple tree" and "bush." Apples symbolize wisdom and joy, and the importance of accepting truth in finding inner peace. Often overlooked, bushes and hedges play a vital role and provide habitats for animals, assist in regulating water supply, and reduce wind speed, which can impact the growth of crops. Consider this symbol and whether there is anything or anyone in your life that seems minor or overlooked, but plays an important part in providing you with safety. How can you encourage this to thrive, securing your peace?

◊ **Mannaz**, the twentieth letter in the Elder Futhark, shares its name with the old Germanic word for "man." It is symbolic of humankind, altruism, and family. Mannaz is a reminder that family and kin are made of individuals who all contribute to the community as a whole, participating in their own unique ways. Meditate on Mannaz as you think of those in your kin—whether family or friends—and the ways their actions support you and others.

◊ **Stan** is the fourth additional rune in the Anglo-Frisian alphabet, translating directly as "stone." Stones are solid and immovable, weathering storms and disasters, and can be used in construction to build and support others. They are an integral part of any landscape and have grounding properties. Hold a stone close to you when you feel the need to ground yourself, thinking of the good in your life and allowing the storm to pass over while your heart fills with gratitude.

Symbols for Courage

Pallas

Morok

Taranis

Eadhadh

Cross of the Moon

Iron

◊ **Morok** is the Slavic deity of lies, darkness, and deceit, but also the keeper of truth. Often portrayed as dark and gloomy, Morok is a reminder that to find the good, sometimes you must push through lies and deceit. It is a difficult but rewarding journey that requires strength and courage. Keep this symbol with you when embarking on a journey that requires courage in the face of adversity to remind you that good will prevail, even if your path seems shrouded in darkness.

◊ **Pallas** is a daughter of Triton, the god of the sea, in Greek mythology. A warrior, she was accidentally killed by her friend Athena after being distracted by the god Zeus. In her sadness and regret, Athena created a statue of Pallas in her honor. Courage is not just to be found in the valiant actions of warriors, but in the recognition of your mistakes and the steps taken to show remorse. When you need to be courageous, place this symbol in a prominent position on your altar to honor Pallas and channel Athena's courage in the face of regret.

◊ **Taranis** is the God of thunder and bravery in Celtic mythology, and was primarily worshipped in Gaul, Britain, and Ireland. He is closely associated with the wheel and was believed to drive the Sun across the sky in a chariot. This is supported by the many wheel-shaped amulets left as votive offerings to Taranis found in excavations. Create your own amulet from clay and carry it with you when the road ahead looks difficult, letting the wheel of Taranis inspire you onward with courage and determination.

◊ **Eadhadh**, the nineteenth letter in the Ogham alphabet, represents the aspen tree. Aspen was traditionally used by ancient Greek soldiers to craft shields, protecting them from enemy attacks. Negative energy can erode your confidence and make it difficult to act bravely. Draw Eadhadh on a plate with salt to protect yourself from those who threaten your strength and courage.

◊ **Iron** is a metallic element known for its strength. This symbol, used to signify iron in alchemy, also represents the planet Mars—named after the Roman god. In Roman mythology, Mars is the god of war, but was also an agricultural guardian, directing his energy toward ensuring the conditions that allowed crops to grow. The strength of both iron and Mars in this symbol shows us that courage requires perseverance and power, and Mars's role as an agricultural guardian also reminds us that courage can be softer and caring. Helping others also takes courage, and is just as worthy a pursuit.

◊ The **Cross of the Moon** is a symbol from Latvian folklore. It is related to agriculture and growth and was seen as a symbol of protection for soldiers. The Cross of the Moon supports personal development, supporting you in assessing where you are in your life and providing the courage needed to make changes. Embroider or draw this symbol on clothing as a subtle reminder to have courage in the changes you are making to grow in yourself.

Symbols for Creativity

Mokosh

Veles

Aquarius

Laguz

Dair

Awen

◊ **Veles**, also known as Volos, is the god of earth, waters, and the Underworld in Slavic Paganism. Veles's name derives from the word *wel*, translated as "wool," and in mythology, he often takes the form of a serpent lying in a nest of black wool. Veles is also known as the protector of traveling musicians and, until the 20th century, musicians in some areas of Croatia continued to spill wine on the ground as a toast to their patron. Draw this symbol in wine or use it to decorate your creative tools to seek protection from Veles.

◊ **Mokosh** is a Slavic goddess who watches over spinning and weaving, and is the protector of women. Archaeological evidence for her worship has been found dating from the 7th to 10th centuries, and she is still venerated to this day as a protector of women. Keep this symbol near when working with fibers so Mokosh can watch over your work, ensuring no stitch is dropped or thread frayed.

◊ **Aquarius** is an astrological star sign that represents someone who is creative, imaginative, and tenacious in pursuing their visions. Like other air signs, Aquarians are known for their innovative view of life that can lead to unique and artistic ideas. They are thinkers and communicators, able to share their views clearly. When you are experiencing an artistic block, draw the sign of Aquarius on a piece of paper and write a list of what is stopping you from achieving your creative goals. Burn the paper to release the stuck energy.

◊ **Laguz** is the twenty-first rune of the Elder Futhark alphabet. It translates as water or lake, and can be called upon to assist in the flow of creativity and intuition. Meditate on Laguz as you envision a dam holding back a raging river. Imagine the water slowly trickling over and building pace until eventually the river rises and crashes through, obliterating any blocks to your creativity.

◊ **Dair** is the seventh letter of the Ogham alphabet and represents the oak, a tree that symbolizes strength, stability, and wisdom. In one of the medieval kennings, Dair is associated with the "handicraft of a craftsman." If you find yourself bouncing between creative endeavors and struggling to focus on a particular task, incorporate Dair into your work to ground you and focus your direction.

◊ **Awen** is a symbol of artistic inspiration. The word awen is a Welsh and Cornish word for inspiration, with its first recorded use in the 8th century. In Welsh mythology, it represents the three elements of inspiration sent from divine beings into the world to act as an inspirational muse to creative artists. Iolo Morganwg, a Welsh language poet in the 18th century, created this emblem to symbolize the three elements of awen spreading into the world. Create a physical interpretation of Awen, such as carved into wood or painted on canvas, to hang by your workspace, to evoke the power of the inspirational muse.

Emancholl

Virgo

Fearn

Symbols for Motivation

Naudiz

Perperuna

Fish

◊ **Virgo** is an astrological star sign that represents hard workers and problem solvers who excel at whatever they set their minds to. This sign's ruling planet is Mercury, the planet of communication, which brings Virgos the ability to open their minds to new information and experiences, giving them a curious and inquisitive nature. If you seek motivation for a task, keep the symbol for Virgo nearby—such as drawn at the top of your notes or as your phone background—and try to look at what you need to do from a Virgoan perspective; approach it with curiosity and an open mind, eager to find the answer or result.

◊ **Emancholl** is one of the *forfeda* or additional letters of the Ogham alphabet. It represents coll, also known as hazel. Hazel is known as a tree of wisdom and a protector of sacred spaces. Place the Emancholl symbol within your workspace to evoke the tree of wisdom and protect your space, driving out any negativity blocking you from your goal.

◊ **Fearn** is the Irish name for the third letter of the Ogham alphabet, representing the alder tree. Fearn and the alder tree symbolize tenacity, determination, and inner confidence, particularly in the face of adversity or difficult circumstances. This symbol is a powerful eliminator of self-doubt, which can cause you to feel unmotivated and unable to complete a task. Much like the alder tree, you hold extraordinary properties that are unique to you. Use this symbol to reconnect with your natural skills and abilities, reminding yourself of how extraordinary you are.

◊ **Naudiz**, an Elder Futhark rune, translates as "need" or "hardship." The tenth rune in the alphabet, it empowers you to have courage and wisdom to seek what must be done in a difficult situation. If you hit a wall and feel unmotivated, Naudiz will help you to identify the issues causing the blockage and fill you with the courage to work through them. Use this rune in meditation to understand what has led you to feeling unmotivated, so you can work toward a solution.

◊ **Perperuna** is the Slavic pagan goddess of rain. Many Slavic and Balkan countries—such as Albania, Bulgaria, and Croatia—have a traditional folk ritual of rainmaking named after her. The ceremonial ritual of singing and dancing was performed by children to bring forth rain in times of drought. When you are feeling a drought of purpose, draw this symbol in a bowl of water to bring forth a flood of motivation.

◊ **Fish** are a positive symbol of good luck, fortune, creativity, and nurturing. They flow with the water, but can also swim against the current, determined to reach their goal. Place a bowl of water in your space and repeatedly draw a fish on the surface as you focus on your goal. Ask yourself what you need to do to regain your motivation, and what actions are needed to get there. Do you need to flow with the water and keep on going to reach your destination, or do you need to change course and swim against the current?

Symbols for Peace

- Yarilo
- Nion
- Monas Hieroglyphica
- Eirene
- Troll Cross
- Saule

◇ **Nion** represents the act of establishing peace. The fifth letter of the Ogham alphabet, Nion aids in bringing together friends, families, and communities for a positive purpose. It is a symbol of activism and working together for a result that benefits all. Draw this symbol in the air with lemon balm or basil incense, letting the energy of Nion fill the space and empower you to take action for a cause close to your heart.

◇ **Yarilo**, or Jarylo, is the Slavic Pagan god of springtime, youthfulness, and peace. In some myths he is the guardian of animals, nurturing them during the spring and ensuring their safety. Carve this symbol into a blue candle and, when lit, stare into the flame. Let the light wash over you, allowing the peaceful, nurturing energy of Yarilo to chase away negative energies you may hold onto.

◇ **Monas Hieroglyphica** is a symbol created in 1564 by a man called John Dee, the court astrologer of England's Queen Elizabeth I. It contains elements of several astrological and alchemical symbols and represents the unity of all creation and spiritual growth. John Dee believed that by meditating on the symbol he could access esoteric knowledge of the interconnectedness of the world, unlocking a profound sense of peace and tranquillity.

◇ **Eirene** is a Greek goddess, venerated as the personification of peace. Annual sacrifices and gifts of olives and honey were made in her honor in Athens to ensure peace for the coming year. She is portrayed as the enemy of revenge, actively seeking to halt actions that could damage peace within Greece. Eirene was also a goddess of plenty and represents the benefit peace brings to humanity. Trace Eirene's symbol in honey on top of porridge or in your cooking to bring a sense of tranquility to your day and stop anything from disturbing your peace.

◇ The **Troll Cross** is an amulet crafted from iron, originally from Norway and Sweden. It acts as a talisman to ward off malevolent magic. While there is some dispute over the origin of the symbol, it has become an apotropaic symbol used to protect the wearer from negative or harmful energy. Wear the Troll Cross to protect your peace from those who wish to disturb it.

◇ **Saule** is a runic symbol, created using a combination of Elder Futhark runes, and translates as "soul." The runes originate from the Thornhill Stone, a carved stone from the 8th century, located in Dewsbury in West Yorkshire, in England. Saule reminds us of the role of inner peace in our lives and the importance of breaking negative patterns and energy that hold you back from truly realizing it. When journaling or doing shadow work, meditate on Saule to uncover these barriers to your inner peace.

Symbols for Grief and Loss

Draumstafir

Triskele

Sail

Eihwaz

Icosahedron

Naed

◊ The **Triskele**, also known as a triskelion, is a symbol that represents life, death, and rebirth. It has been found in archaeological sites in Malta dating to 4400–3600 BCE, as well as in a Megalithic tomb in Newgrange, Ireland, from 3200 BCE. The Triskele signifies the cyclical nature of existence and provides a broader understanding of our life's journeys within the natural world. Paint or engrave the Triskele on a rock and, mirroring the ancient practice, place it near the memorial to a lost loved one.

◊ **Draumstafir** is an Icelandic stave used to dream of unfulfilled desires. Recorded in the Huld Manuscript in 1860, the reader is directed to scratch the symbols on white or silver leather—although any fabric can be substituted—on St John's Eve (June 23) and place it under your bed as you sleep. Grief is a complex emotion and you can feel loss for situations besides someone's passing: for a dream never realized, an opportunity never taken, or a friendship no longer around. Use Draumstafir to dream of those unfulfilled desires one last time before taking steps toward healing.

◊ **Sail,** or Saille, is the fourth letter of the Ogham alphabet and represents the willow tree. The willow is a symbol of new life, as a branch of the tree will take root when placed in the group. Its ability to grow and survive through difficult circumstances is symbolic of humanity's ability to cope with great hardship and loss. Hang the Sail rune, crafted from twine and twigs, in your home; it will carry the enduring energy of the tree into your life.

◊ **Eihwaz** represents death, rebirth, and surviving through challenges. The thirteenth rune in the Elder Futhark alphabet, it symbolizes the yew tree—a tree that remains evergreen, even through the toughest winters. Embroider Eihwaz onto your sleeve so you can look upon it regularly to remind yourself that, like the yew tree, you will get through this difficult time.

◊ The **Icosahedron** represents water in sacred geometry. The fifth and final platonic solid, and one of the building blocks of life, the icosahedron symbolizes transformation and the natural flow of life. Much like water, grief ebbs and flows. It is overwhelming but also shows the impact those you have lost have had on your life, and that your heart is capable of great love. Some days will be easier than others, but even if you feel trapped, remember that you are still moving forward.

◊ **Naed**, also known as Naudiz, is an Anglo-Frisian rune symbolizing need and hardship. The tenth rune in the Anglo-Frisian alphabet, it is recorded in three British poems from the 7th century. One of the poems describes Naed as oppressive to the heart, but also a source of help and salvation. Sorrow is not only the sadness felt from being separated from those you love, but is also a direct link to the love you received and gave. Paint or carve Naed onto a flat stone collected at a place that holds fond memories of your lost loved one and place it among perennial plants. As they grow around Naed, so too will you grow around your grief.

Symbols for Physical Wellness

Symbols for Better Sleep

- Lyra
- Moon
- Crow
- Ing (Elder Futhark)
- Svefnthorn
- Hypnos

◊ The **Moon** symbolizes our inner feelings and desires, and our true selves. It is in a constant state of change, moving through its phases, and recent research suggests the Moon's phases may have an impact on the quality of your sleep. You go through similar cyclical changes in your own life, which can impact how restful and rejuvenating your sleep can be. Focus on the symbol of the Moon as you assess what aspects of this phase of your life are obscuring your true self, and what steps you can take to rectify them.

◊ **Lyra,** a constellation situated in the Northern Hemisphere, is named after the lyre of Orpheus. In Greek mythology, Orpheus' music was said to quell the voices of Sirens as they tried to lead the Argonauts astray. Negative thoughts can distract you from sleep, keeping you awake or causing unpleasant dreams. As you wind down for sleep, light a blue or white candle with the Lyra symbol carved into it to quell the negative thoughts, chasing them away before you are led astray.

◊ **Crows** are messengers from the spiritual realm, carrying information from deities and guiding us on Earth. They represent foresight and intelligence, alerting you to a coming change in your life. Use this symbol for crows, depicting crow's feet, in journaling and meditation, focusing on the image as you assess what is needed to improve your sleep, or reflect on whether changes in your life are impacting you in a bigger way than you thought.

◊ **Ing (Elder Futhark)**, also known as Ingwaz or Inguz, is the twenty-second rune of the Elder Futhark alphabet and symbolizes rest, internal growth, and time for oneself. It is named for the Old English deity Ing, god of peace, prosperity, and fair weather. Sew the Ing rune into your pillowcase, or a bag of dried lavender, to promote deep, peaceful sleep where energy is accumulated and the healing process can happen.

◊ **Svefnthorn** (svefnþorn) is an Icelandic stave believed to have the power to induce your enemies into sleep. However, when paired with positive intentions and symbols, Svefnthorn can also be used to provoke a deeper sleep for yourself. Carve this stave into wood, or draw it on a piece of paper, and place it under your bed to help you drift off. Pair Svefnthorn with a crystal of positivity, such as fluorite or ocean jasper, to ensure your sleep is rejuvenating and your dreams are pleasant.

◊ **Hypnos** is the personification of sleep in the Greek pantheon. Although Hypnos lived with his twin brother Thanatos, who represented death, in the Underworld, he was viewed as a gentle and calm deity who would seek out and assist humans in need. The word hypnosis—to put someone into a sleep-like state—is derived from his name. Keep this symbol near your bed, either alone or among symbols of Hypnos such as poppies and chamomile, to invoke his presence for a peaceful sleep.

Symbols for Good Dreams

Silver

Neptune

Sulfur

Draumstafur

Unicursal Hexagram

Sycamore

◇ **Sulfur**, also known as brimstone, is a powerful apotropaic symbol for protection and banishment. In alchemy, sulfur represents the soul and our true selves. Embroider the symbol of sulfur onto a pouch of lavender and keep it under your pillow, or draw the symbol on your headboard in lavender oil to banish negative energy from your mind and protect your dreams as you sleep.

◇ **Silver** symbolizes contemplation and wisdom, and is associated with the Moon's energy and lunar magic. It represents balance and harmony and contributes to a peaceful sleep environment. If you do not have any silver to place in your bedroom, draw this symbol on your window. Charged by the Moon's energy, it will bring a sense of peace to the space and provide a tranquil environment for positive dreams.

◇ **Neptune**, named after the Roman god of the sea, is associated with dreams and creativity. In astrology, this planet represents intuition and illusion, helping you to escape reality through art, spirituality, and dreams. Neptune is a reminder to keep an open mind, encouraging you to embrace the unknown and try new opportunities in the pursuit of your goals. Use this symbol in art or journaling to attract Neptune's creative energy into your life and dreams.

◇ **Draumstafur** is an Icelandic stave, and a symbol imbued with magical intention. This stave was created as part of a ritual to control the dreams of someone. Carve the Draumstafur stave into a piece of wood while envisioning the dreams you wish to have, and place it under where you sleep. Due to its historical provenance, this is a potent symbol, empowered with centuries of use.

◇ The **Unicursal Hexagram** symbolizes the union of the spiritual and physical worlds. Although this symbol has been in use for centuries, it was popularized by Aleister Crowley in the 1900s as a symbol for Thelema, an occult movement. Place a drawing of the Unicursal Hexagram near your bed every night to strengthen your connection with the spiritual state, helping you to have more control over the content and tone of your dreams.

◇ **Sycamore** trees symbolize the connection between Heaven, Earth, and the Underworld. In British folklore, sycamore leaves were believed to have the power to ward off maleficent spirits and protect from illness. The leaves would also be placed under a pillow to ward off bad dreams and restless sleep. Place a dried sycamore leaf, or a drawing of one, under your pillow before bed to promote restorative sleep, fending off negative energy and nightmares.

Symbols for Relaxation

Calc

Air

Salacia

Psyche

Horse Chestnut

Icelandic Stave

◊ **Air** is a vital life force and the flow of energy that animates the world. Air is all around you but, since it is intangible, can be difficult to connect with. Focus on the alchemical symbol for air as you envision it swirling around you, wrapping around your body and slowly filling your lungs as you breathe in and out. Practice this deep breathing exercise when you require calming and relaxing energy.

◊ **Calc**, one of the additional runes of the Anglo-Frisian alphabet, represents a chalice and, in divination, symbolizes the ending of a process, resulting in personal or spiritual transformation. Calc is a reminder that at times the best course of action is to allow something to come to its natural conclusion rather than expending energy best used elsewhere. You do not have infinite reserves of energy, and you cannot care for yourself if you are burned out. After all, you cannot pour from an empty cup—or an empty chalice. Draw Calc onto your water bottle to serve as a regular reminder to take a restorative moment for yourself amid the chaos of the day.

◊ **Salacia** is the Roman goddess of salt water. She embodies all characteristics of the ocean; the turbulent, crashing waves, and the calm and sunlit aspects of the sea. Salacia is a reminder of the immeasurable depths within all of us. During tumultuous times, when you feel like you are in the midst of a raging storm, draw this symbol on your skin with water as you picture the calming, gentle waves Salacia presides over, washing over you.

◊ **Psyche** is a Greek goddess who represents the personification of the soul. In Greek mythology, Psyche fell in love with the god Eros, but underwent many trials before they could be together. The story of Eros and Psyche—symbolizing the connection between love and the soul—teaches that even after enduring trials and tribulations, our souls can find peace. Invite calm into your space and soul by tracing this symbol in the air with lavender incense.

◊ **Horse Chestnut** trees symbolize stability and resilience. They can adapt to a wide variety of soil types and weather conditions, and their roots run strong and deep within the earth. Horse chestnuts, also known as conkers, are apotropaic symbols, protecting negative energies when placed in the home or carried on your person. Place conkers and horse chestnut leaves near you when in need of relaxation, to ground yourself and protect your peace.

◊ This **Icelandic Stave** was created to protect against the overwhelming sense of foreboding when entering into darkness. Recorded in 1800 CE, but believed to have been in use for centuries, this stave should be worn under the arm to protect against the feeling of fear and apprehension when facing an uncertain or unclear situation. Anxiety can rob you of personal peace, making relaxation seem impossible. Use this symbol, drawn on the skin or embroidered onto clothing, to protect yourself from negative energy and allow a sense of calm to thrive.

Symbols for Energy

- Mars
- Ear
- Tau
- Þjófastafur
- Uruz
- Zeus

◊ **Ear** is an Anglo-Frisian rune believed to represent earth. Connecting with the natural world has long been utilized to boost energy and wellness, but recent studies suggest there is a scientific foundation for this practice. Draw Ear in the soil or sand to direct revitalizing energy toward you and spend time resting among nature, to ground yourself and rebuild your depleted reserves.

◊ **Mars**, the fourth planet from the Sun, is the planet of desire and energy. Named after the Roman god of war and agriculture, it is a fiery and active planet full of barely contained energy. Mars is dynamic and powerful, encouraging you to embrace your strengths, take action, and fight challenges with courage. When your drive to forge on is depleted, spend a few minutes each morning meditating on this symbol. Carry it with you throughout the day to breathe fire into your actions and face any trials head-on.

◊ **Tau**, the nineteenth letter of the Greek alphabet, symbolizes life and resurrection. In physics and engineering, Tau is used to denote the Time Constant, or the speed at which a system responds to change. A big change or tumultuous time can lead to depleted energy, and it can be difficult to come to terms with recovery. Tau represents the cyclical nature of life, that all things end and are resurrected in some capacity, while also reminding you that every person responds to changes at different speeds and in different ways.

◊ **Þjófastafur** is an Icelandic stave created to assist in identifying thieves. The stave was to be carved or drawn onto the bottom of a wooden bowl which, when filled with clean water and yarrow, would reveal the face of a thief. Many internal and external factors can impact or steal your energy, although they are not always easy to recognize. Follow the original instructions for Þjófastafur to assist with identifying what's lowering your energy so you can take action to rectify the issue.

◊ **Uruz**, also known as Ur, is the second rune in the Elder Futhark alphabet. A symbol of physical power, endurance, and stability, Uruz is a reminder that energy is not always easily gained; sometimes it must be developed through persistence and dedication. If you are working toward building your energy through physical or emotional development, mark an item associated with your journey—such as a water bottle or journal—with Uruz to support you.

◊ **Zeus** is the Greek god of the sky, thunder, and lightning. The king of the gods, Zeus personifies the strength and power of the natural world. Zeus can manipulate lightning, a force that can wreak havoc on the natural landscape, bending it to his will. While you may have the energy you need to complete a task or activity, identifying the best way to exert it is not always simple. Light a red candle with Zeus's symbol carved into the wax to help focus your energy where it is needed, rather than wasting any on unnecessary actions or people.

Symbols for Sexual Energy

- Apple
- Fire
- Lepus
- Taurus
- Sheela Na Gig
- Icelandic Stave

◊ **Fire** has a core role in the alchemical process. A catalyst for transformation, it is part of the final step for transmuting everyday elements into gold. Without that fire—the heat, the drive, the passion—the final goal could not be achieved. To locate and revive your own desire, burn a loose incense blend of dried rose petals, cloves, and myrrh, and—using the cooled ashes—draw the alchemical symbol for fire on a piece of paper. Fold the paper and keep it close to your heart.

◊ **Apples** symbolize knowledge, desire and temptation. They have long been connected to fertility and sexuality. They are often used to represent the fruit that led to the expulsion of Adam and Eve from the Garden of Eden; were bestowed by the Norse goddess Idun to maintain youth and vitality; and were gifted as tokens of love in ancient Rome. Due to their long history of association with seduction and sensuality, they are a powerful symbol. Keep this symbol in your room—or wherever you engage in high-intensity activities—to call on this power, fueling your libido and stimulating your desire.

◊ **Lepus**, a constellation south of the celestial equator, is represented by a hare or moon rabbit. Rabbits are closely linked to fertility and frantic sexual energy, largely due to their very active mating season in spring. Channel this enthusiastic, boundless energy by embroidering the symbol of Lepus on a charm bag filled with dried marshmallow and mint leaves and placing it under your bed to bring fertility and abundance to sexual activities.

◊ **Taurus** is a sensual star sign. Taureans are ruled by Venus, the planet of love, and are highly physical. They love the physical manifestations of comfort: soothing aromas, pleasing sounds, decadent tastes. Channel your inner Taurean to boost your sexual energy, focusing on the act itself and your environment. Etch the symbol into a red candle and light it, surrounding yourself with sultry scents, blankets, and indulgent food to stimulate your entire body.

◊ This **Icelandic Stave** was recorded in a 17th-century manuscript. It provides protection from embarrassment and insecurity. The manuscript directs the reader to draw the stave on your forehead in spit—or water—to ensure no shame is felt. Use this ritual to boost your self-confidence, and take steps toward breaking down any shame imposed by a patriarchal society on sexual, sensual bodies.

◊ **Sheela Na Gigs** are figurative carvings, commonly found in Ireland, Britain, and France, dating from the 11th century. They were carved into the walls of churches and castles as an apotropaic symbol to ward off evil and protect those in the building. Sheela Na Gigs depict a naked woman, legs akimbo, displaying her vulva. Some archaeologists believe they are a remnant of pre-Christian religion that celebrated the female body and sexuality. Sheela Na Gigs are not overtly sexual—they simply show the female body—but they exude confidence in its power and strength. Display Sheela Na Gig in a prominent position in your bedroom as a celebration of your sexuality and physical power.

Waning Gibbous Moon

Jupiter

Pictish Serpent and Spear

Symbols for Personal Wellness

Hygeia

Saulė

Iodhadh

◊ **Jupiter**, the fifth planet from the Sun, is associated with healing and good fortune. Named after the Roman god of the sky and thunder, it is the largest planet in our solar system. Jupiter is associated with mental and spiritual growth and supports you in your journey of self-discovery and improvement. Keep this symbol near to encourage you to work toward personal growth, casting off that which does not serve you and nurturing that which brings you joy and peace.

◊ The **Waning Gibbous Moon** phase is a time for healing and re-evaluating your goals. As the Moon begins its transition back to darkness, it creates the perfect time to slow down and reflect on life. Letting go of the past and allowing yourself to heal is vital for physical and mental wellbeing. Use the Waning Gibbous in journaling during the Waning Gibbous phase to guide you in assessing your current position in life, and identifying what is no longer supporting you.

◊ The **Pictish Serpent and Spear** symbol—also known as a serpent and Z rod—is from a standing stone in Inverurie, Scotland. Originally part of the Brandsbutt stone circle, it was crafted around 600 CE. The serpent is believed to symbolize medicine and healing, while the Z rod represents a broken arrow or spear. Draw this symbol of a healing serpent entwined around a broken weapon on your favorite water bottle as a reminder that even the fiercest warriors require time for healing and care.

◊ **Hygeia** is the Greek goddess of health, cleanliness, and hygiene. She represents the prevention of sickness and the continuation of good health. To promote personal, physical, and mental wellness, draw this symbol in a bowl of water and then use it to wash your hands, envisioning negative energy and any obstacles to maintain your wellbeing washing away.

◊ **Saulė** is a solar goddess in Baltic Pagan tradition. As one of the most powerful deities in the pantheon, Saulė determines the wellbeing and renewal of all life on Earth. She represents health and harmony and brings light into the darkness. Draw this symbol on paper or embroider it into clothing and leave it in the sunlight to absorb the healing power of Saulė. Carry it with you to infuse your day with positive solar energy.

◊ **Iodhadh**, the twentieth letter in the Ogham alphabet, represents the yew tree. Yew trees symbolize everlasting life, death, and resurrection, and are known as the tree of life throughout the Northern Hemisphere. It has historic and modern medicinal uses, including a treatment for cancer developed from the Pacific yew tree. Yew trees can live for hundreds of years, constantly regenerating and growing, even as the inner core dies and becomes hollow—often this void becomes a home for wildlife. The Iodhadh symbol is a reminder that even when an older part of you ceases to exist you can continue to grow and flourish, creating a space of sanctuary and safety within your core.

Symbols for the Sabbats

Symbols for Yule

- Holly
- Daisy Wheel
- Yule
- Ouroboros
- Isa
- Koliada

◇ **Yule**, also known as the winter solstice, marks the longest night of the year. During this time lights and candles are lit to symbolize the return of daylight and rebirth of light, as the nights begin to once again grow shorter. Focus on rebirth and renewal during Yule, using this Neopagan symbol in your grimoire or during celebrations to symbolize the Sabbat.

◇ **Holly** has long been associated with the festive season. In Celtic mythology, the Holly King ruled over the colder half of the year, and in British folk tradition, a boy and girl dressed in holly paraded through the village as a way of bringing nature back into the darkest part of the year. Holly reminds us that nature still blooms and grows through the darkest times. Use this symbol during Yule celebrations to honor ancestral folk traditions and as a reminder that light will always follow the dark.

◇ **Daisy Wheels** (also known as Hexafoils) are apotropaic symbols found throughout Britain and northern Europe. Some have even been found in Australia and North America, likely brought over by migrants. They were engraved on the interiors of buildings from the 16th to 18th centuries to protect them against evil and misfortune. It is believed the Daisy Wheel was used to emulate the Sun, shining light into dark corners so evil could not lurk there. Carry this symbol with you when you need to shine light into the darker parts of your life, or use it in your Yule celebrations to remind yourself of longer, brighter days ahead.

◇ **Ouroboros** is an ancient symbol, depicting a snake eating its own tail. Appearing in both Egyptian and Greek art, it symbolizes the eternal cycle of life and death. During Yule we often look ahead to the new year, making plans and setting intentions for the next twelve months. As Ouroboros represents the cycle of renewal, focus on the symbol as you assess your goals for the new year. You may feel stuck in certain areas, but life is full of renewal and change.

◇ **Isa**, the Elder Futhark rune, translates as "ice." During the darkest part of the year, life can feel frozen, yet there is still movement. Use this time to appreciate the stillness and concentrate on small, gradual changes that move you closer to your goals. Focus on Isa during shadow work or manifestation, allowing the gradual but purposeful movement of glaciers and ice to remind you that there is strength in taking your time.

◇ **Koliada** is a Slavic deity that personifies the newborn winter Sun. During the period between Christmas and the Epiphany, some Slavic countries, such as Ukraine and Belarus, continue to observe pre-Christian rituals in honor of the winter solstice. Celebrated at the end of December, the festival bears the same name as the deity. Draw the Koliada symbol on thin, colored paper and place it on a window. As the Sun shines through, the color will flood the room, reminding us that while the world may seem dark, the Sun still shines—you just have to find it.

Symbols for Imbolc

Brigid's Cross

Imbolc

Metenis

Pictish Sun Disk

Ifín / Pín

Īor

◊ **Imbolc** is a Neopagan emblem created to symbolize the Sabbat. During Imbolc, or St Brigid's Day, we celebrate the return of the Sun in the upcoming spring and the passing of the darkest nights. Imbolc is a time to celebrate our strengths and achievements while looking forward to brighter times. Decorate your altar with spring flowers and foliage in the shape of the Imbolc symbol to celebrate the Sabbat and upcoming season.

◊ **Brigid's Cross** symbolizes Brigid, an Irish deity associated with wisdom, healing, and protection. The feast day of her Christian counterpart, St Brigid, is celebrated on February 1 and was known as Imbolc. Brigid's Crosses are woven from rushes during the festival and are hung in the home for the rest of the year to bring blessings and protection to the family. The cross itself symbolizes the goddess and can be used in rituals to evoke the healing and protective nature of Brigid.

◊ **Metenis** represents the ancient Latvian festival, annually held in February to celebrate the coming of spring. During Metenis, bonfires are lit and wreaths, created during the previous summer solstice, are burned to assist in driving winter away. Some believe that the longer the festival is celebrated, the bigger the return will be from the year's harvest. Draw the Metenis symbol on paper and place it in a dish to burn, mirroring the practice of setting summer solstice wreaths alight, to bring abundance and prosperity to your life in the upcoming spring and summer seasons.

◊ **Pictish Sun Disks** were engraved on standing stones throughout north and northeastern Scotland from the 4th to 7th centuries. Archaeologists believe the symbol was widely used to represent the Sun, and its presence on carved megaliths suggests it was venerated by the Picts. As the days lengthen, the Sun brings more light and, with it, the beginnings of spring. Use this symbol in your celebrations as a way of paying homage to ancestors and to the power of the Sun.

◊ **Ifín/Pín,** the fourth of the additional letters of the Ogham alphabet, represents the gooseberry bush. In the Victorian language of flowers, gooseberry flowers symbolized anticipation. Traditionally, Imbolc is a time to prepare for the coming spring by sowing seeds, hoping for a fruitful harvest. Embroider or draw Ifín on a cloth bag. Write your intentions for the season on a piece of paper and place it inside. Sew the bag closed, focusing on your anticipation to experience the results of your work as your motivation to achieve.

◊ **Īor**, an Anglo-Frisian rune, is often interpreted as "eel." Eels symbolize the cyclical nature of life and the landscape, as well as endurance and perseverance. They thrive in difficult conditions and can pass through the obstacles of drier land in their quest for a new habitat. Using twigs and flowers, craft the symbol of Īor and place it in your home on Imbolc. As the seasons change, eels remind us that strength can be found in the most challenging of places, and that obstacles can be overcome with perseverance.

Symbols for Ostara

Flora

Ostara

Leaping Hare

Mara

Butterfly Mark

Earth (Alchemical)

◊ **Ostara**, also known as the spring equinox, is a celebration of the fertility of nature and natural growth. The name Ostara comes from the Old English and Germanic goddess Eostre, who brings renewal and rebirth from the darkness of winter. The deity and her celebrations later gave their name to the Christian holiday of Easter. This Neopagan symbol was created to represent the Sabbat and can be used to honor the deity. Using paint and pressed flowers, decorate an air-blown or hollowed egg and place it on your altar for Ostara as a symbol of renewal and rebirth.

◊ **Flora**, the Roman goddess of flowers, symbolizes the renewal of the cycle of life in spring. Her festival lasted for several days and focused on fertility, and the hope for an abundant natural landscape after the darkness of the winter months. Place this symbol, created to represent the asteroid named after her, wherever you wish for hope and prosperity to bloom.

◊ **Leaping Hare** symbols are found in many cultures. In Egyptian mythology the hare leapt between genders in correspondence with the waxing and waning moon cycles. In 16th-century Britain, Witches were believed to metamorphose into hares, and they are closely connected with Eostre, the Old English goddess of springtime. Hares are symbols of vitality and fertility, themes associated with Ostara and the Sabbat's namesake of Eostre. Honor hares and their historic association with the festival by using the symbol marked onto candles or painted onto stones for your altar.

◊ **Mara** is a Pagan Slavic deity associated with winter's death and the rebirth of nature. In folk tradition, an effigy of Mara is drowned or set on fire to symbolize the end of winter and beginning of spring. Draw this symbol on a piece of paper and place it in a bowl of water to replicate this custom, signifying the end of dark days and bringing forth the light of the coming season.

◊ **Butterfly Mark** is a apotropaic symbol used between the 16th and 20th centuries in Britain to protect buildings from evil spirits. Archaeologists believe the mark developed from the Dagaz Futhark rune, which symbolized day, and was used as a way of shining light into dark spaces to prevent evil from lurking there. Embroider a Butterfly Mark on a charm bag filled with dried rose petals, rosemary, and bay leaf to protect against dark forces, whether from others or from your own worries.

◊ The **Earth (Alchemical)** symbol represents home, growth, and support. While the natural landscape around us changes dramatically with new growth and blooming flowers, it is easy to be swept away with new possibilities and neglect our current plans. Earth reminds us to maintain an awareness of where we are and grounds us, while ensuring we can still explore and appreciate new changes and opportunities. Keep this symbol in a place you will regularly see it as a reminder to stay grounded among changes around you.

Symbols for Beltane

Beith

Beltane

Horned God

Berkana/ Bjarka

Eunomia

Hawthorn

◊ **Beltane** marks the midpoint between the spring equinox and summer solstice. Also known as May Day, it has been celebrated in numerous cultures for centuries, with many traditions such as bonfires and maypoles still being observed today. A time for joy, Beltane focuses on the fertility of the land and upcoming new life. Craft the emblem for Beltane with twigs to decorate your altar, using ribbons to symbolize the traditional May Day maypole.

◊ **Beith** is the first letter of the Ogham alphabet and can be translated as "birch." As birch trees grow new leaves in the spring, they are associated with fertility and new beginnings, and their wood is traditionally one of those used for besoms and Beltane fires. If you are unable to attend a Sabbat celebration, draw this symbol on paper with ash to represent the Beltane fires in your own rituals.

◊ **Horned God** has existed in many forms as Pan, Faunus, Herne the Hunter, and Cerunnos. The god of nature, sexuality, and hunting, the Horned God is often associated with the darker half of the year. However, at Beltane he unites with the Mother Goddess in passion, symbolizing the transformation of the natural landscape from cold and dark to fertile and abundant. Beltane is a time when we, like the Horned God, surrender our boundaries to become more than just ourselves. Use this symbol in journaling as you explore the steps needed to push your boundaries and grow.

◊ **Berkana/Bjarka** is a symbol of birth. An Elder Futhark rune, it is also used in divination to represent change, growth, and partnerships. At a time when we celebrate the flourishing natural landscape, full of new life and growth, Berkana can be used to channel this positive energy into your practice. Engrave the symbol into a white, green, or red candle to be lit during a ritual to evoke the symbolism of springtime celebrations and Beltane fires.

◊ **Eunomia** was one of the Greek goddesses of law and legislation, and also of springtime and green pastures. Alongside her sisters—the Horæ—Eunomia was the deity of fast-fleeting hours, helping to prepare the Sun for its daily race across the skies. Although Eunomia represents the lush greenery of spring, she also reminds us that time is fleeting. Use this symbol in your rituals to represent your gratitude for the changing season and as a reminder to not take the fleeting beauty of nature for granted.

◊ **Hawthorn** trees were traditionally a center point for May Day celebrations in England. Hawthorn boughs, cut down and decorated with wildflowers, were known as May Day bushes. Use this symbol to honor historic customs for celebrating Beltane, incorporating it into your Sabbat celebrations. However, do not use this symbol inside your home—in Irish folklore, hawthorn trees and blossoms cause bad luck if allowed in, bringing with them illness and even death.

Symbols for Litha

Jāṇi

Litha

Kupala

Cēn

Óir

Concentric Circles

◊ **Litha**, also known as the summer solstice and Midsummer's Eve, marks when the day is at its longest. It marks the beginning of the harvest season and symbolizes strength, growth, and success. Use this Neopagan symbol to represent the Sabbat and as a reminder that, eventually, all lingering nights will give way to longer, brighter days.

◊ **Jāņi** is a traditional Latvian folk festival celebrated during the summer solstice. During the celebrations, folk songs are sung, plants from the local area are gathered and used to decorate the home—specifically those that repel evil spirits—and bonfires are lit that burn throughout the night to bring good luck and health in the upcoming darker half of the year. Incorporate this symbol into your Litha rituals to channel the cumulative power centuries of solstice celebrations hold.

◊ **Kupala** is a folk festival held during the summer solstice, featuring traditions and rituals believed to originate in pre-Christian Belarus and Ukraine. On this night, Witches and ghosts were said to roam the Earth seeking to inflict harm, while animals and plants could speak. Today, rituals such as jumping over bonfires to bring joy to the upcoming year are part of the festivities. Ancestors completing these rituals for centuries have bolstered their power, making the symbol of Kupala a strong emblem of positivity and light. Draw this symbol with the cooled ashes of loose incense at your home's entrance, inviting in joy and hope.

◊ **Cēn** is the sixth letter of the Anglo-Frisian runic alphabet and translates as the word "torch." This interpretation comes from an Old English poem: "The torch is known to every living man... it always burns where princes sit within." Cēn reminds us that all of us—no matter our position or authority—can experience the warmth and power light brings. During the summer solstice, carry Cēn with you to invite sunshine and light into your life.

◊ **Concentric Circles** were incredibly common apotropaic marks found from northern Europe through to Australia between the 10th and 19th centuries. They were engraved into buildings, both homes and public, to deter evil from entering. As they were circles, they held no corner for evil to hide within. Some archaeologists believe they were created to resemble the Sun, bringing the light of nature into a building and ensuring that no darkness would linger. Adorn your home or space with Concentric Circles during the longest day of the year, embracing the light and keeping it with you as the days begin to shorten again.

◊ **Óir**, one of the *forfeda* (additional letters of the Ogham alphabet), represents the spindle tree. The tree's latin name *Euonymus* translates as "lucky," somewhat ironically, as all parts of the tree are poisonous to humans. In other readings of the Ogham, Óir is interpreted as the element of gold and represents luck and good fortune. As Litha is a time of transformation, work with this rune when manifesting positive changes in your life.

Symbols for Lammas

Corn Dolly

Lammas

Scythe

Aka

Sheep

Ing
(Anglo-Frisian)

◊ **Lammas**, also known as Lughnasadh, is one of the harvest festivals and marks the middle of the summer. During Lammas grain is harvested and baked into bread to celebrate the generosity of the natural landscape and the results of our hard work. Lammas is the perfect time to reflect on how the year has gone, and what can be done to continue your success. Fashion the symbol for Lammas out of stalks of wheat or other grains, placing it upon your altar as you celebrate the Sabbat.

◊ **Corn Dollies** were part of a harvest custom popular in pre-industrial Europe. A common folk belief was that of the "corn spirit," which lived among the crop and ensured a good harvest for the coming year. However, when the grain was harvested the spirit would become displaced. Corn dollies were created from the last piece of corn to be harvested, ensuring the spirit had a home until the dolly was returned to the soil when the next crop was sewn. Place this symbol in a central position and keep it on display to pay homage to ancestral traditions and ensure abundance for the next year.

◊ **Scythes** are traditionally used to mow grass or harvest crops but have also come to symbolize death. Lammas is a time of life but also death, as the death of the harvested grains is necessary to provide us with food. Focus on this symbol during journaling, or incorporate it into art as you ask yourself: What am I hoping to harvest? What can I do to ensure a bountiful harvest? What must I sow to get there? And what needs to be cut from my life to allow me to flourish and truly live?

◊ **Aka**, also called a double cross, is a Latvian symbol that signifies the start of the agricultural year. It represents new possibilities and beginnings. During the first harvest, we celebrate the return of our hard work and gain insight into how the ongoing harvest will play out. Carve the Aka into a bright gold or yellow candle and burn it as you celebrate the fruits of your labor.

◊ **Sheep** have been entrenched in symbolism throughout numerous cultures and civilizations. While mainly associated with following the crowd and fertility, they also symbolize community, peace, and humility. This sheep symbol—from the Mycenaean Linear B alphabet—was found on tablets created to record shepherd's flocks in Crete in the 14th century BCE. The sheep symbol reminds us that abundance is not about gaining financial or material wealth—we can also be rich in the community we have, the peace we feel, and in the flock we gather with. Keep this symbol in your wallet or purse to attract abundance, both financial and spiritual.

◊ **Ing (Anglo-Frisian)** represents the Old English deity Ing. Believed to be an older version of the Norse god Freyr, Ing is associated with peace, prosperity, and good harvest. In the 13th-century manuscript *Prose Edda*, the author states Ing ruled over the rain, the shining of the Sun, and the fruits of the Earth. Incorporate this symbol into all of your rituals during Lammas for an abundant harvest season, agriculturally or in your own life.

Symbols for Mabon

Wine

Mabon

Apple Cross Section

Gratitude

Ceres

Jera/Jara

◊ **Mabon** is a Neopagan symbol created to represent the Sabbat. During Mabon, or the fall equinox, we harvest and celebrate the fruits of our labors. While this traditionally meant the plants were harvested, it is also a good time to celebrate our own successes. Using the symbol for Mabon as a focus point, list your past successes and hopes for the coming season. Place the rolled-up list in a small jar with dried apple, cinnamon, and rose petals, and seal it with red or orange wax to ensure success for your upcoming ventures.

◊ **Wine** is closely related to abundance and plenty. As Mabon marks the height of the harvest season, it is the ideal time to celebrate the gift of nature's bounty. This symbol for wine was created by an ancient Mycenaean civilization, in which wine was an integral part of their culture, religion, and economy. This symbol can be used in magical practice—drawn on paper, painted onto rocks, or carved into wood—to symbolize the centuries-old reverence for the drink.

◊ The **Apple Cross Section** has a special meaning in Witchcraft—the five seeds represent the pentagram and are a reminder of the connection between nature and magic. Apples' link to magic, abundance and wisdom is present throughout folklore; in Greek and Norse mythology, apple trees represented immortality, while Merlin gained his gift of prophecy by eating apples from an enchanted orchard. Place a dried out apple slice as a Mabon decoration on your altar, to invite abundance and wisdom into your life.

◊ **Gratitude** is a central aspect of Mabon. The second harvest sabbat, Mabon is traditionally when those who worked the land would know how their crops and animals would fare. As such, it is a time to give thanks for the harvest, for the gifts bestowed by nature, and for the promise of the reward yet to come. As Mabon falls more than halfway through the year we can start to see the rewards of our hard work come to fruition. While it can be difficult to see the good, especially during times of global uncertainty, this sigil was crafted to act as a reminder to look for the positive in the everyday and to celebrate it, however small. Keep this symbol in your wallet or purse, or tucked under the case for your phone, to inspire you to seek daily gratitudes.

◊ **Ceres** is the Roman goddess of agriculture, grain, fertility, and motherly relationships. Use this symbol in your Sabbat celebrations and rituals to represent your hopes for an abundant and bountiful harvest season, whether agriculturally or on a more personal level.

◊ **Jera/Jara**, the Elder Futhark rune, translates as "year." In divination, it is a rune of peace and plenty, but also of justice and consequences. Although Mabon is a time of abundance, the results of your labors may be abundantly good as well as bad. Jera reminds us that what we sow bears consequences and, without the proper cultivation and care, we may not like what we reap.

Symbols for Samhain

Oak

Samhain

Crescent and Arrow

Salt

Mesh

Persephone

◊ **Samhain** is a symbol created recently to represent the Sabbat. Samhain coincides with Halloween (or All Hallow's Eve) and marks the Celtic New Year. It is when darkness reaches its height and the space between our world and our ancestors is at its thinnest. Samhain is a time to honor ancestors, remember those who have passed, and to release anything we no longer hold space for. With ribbons or yarn of black, orange, and white, braid a long length of cord and outline this symbol on your altar during the Sabbat as a focus point for your celebrations.

◊ **Oak** trees represent endurance, even in the harshest of weather. As the days grow shorter and the nights longer, collect oak leaves and place them around your home to imbue your day with fortitude and strength, or draw them as a reminder that from small acorns, mighty trees can grow.

◊ The **Crescent and Arrow** symbol is a popular image in Pictish art. The symbol, found carved into standing stones dated to the 4th century CE, represents the soul's journey entering and then leaving the Earth. As we remember the dead during Samhain, the Crescent and Arrow image is ideal to honor the practices of our ancestors and those whose lives have left the Earth, in your own magical work. Place a drawing of this symbol near photos or mementos of lost loved ones, alongside flowers and their favorite food or drink, to honor their memory.

◊ **Salt** is a purifier and repels evil. At a time when the veil between worlds is at its thinnest, salt provides protection from maleficent forces. When you feel the need to repel evil—whether this is spirits or others' intentions—keep this symbol on you at all times. It can also be used to represent salt in ritual work, if you're unable to use the physical version.

◊ **Mesh** patterns have been used for centuries in Britain as apotropaic symbols, scratched into walls and furniture to provide protection. It is believed they symbolized a net to catch evil from entering. They are usually found near entranceways to a building, etched into doorways, and carved above fireplaces. Place these symbols—either carved or drawn on paper—near doors and windows to trap negative spirits or intentions that threaten your peace.

◊ **Persephone**, or Persopina in the Roman Pantheon, was the daughter of Zeus and Demeter, the Greek goddess of the harvest and agriculture. Abducted by Hades, she lived in the Underworld for half of the year. The death of plants and the longer nights of fall were believed to be caused by her mother's grief at the loss of her daughter. Persephone's yearly ascension to her throne in the Underworld reminds us that, although the days may be shorter and less forgiving, the cycle of the wheel moves on and the brighter days of spring shall return again.

Symbols for the Moon

Symbols for the New Moon

- Water
- New Moon
- Haglaz
- Polaris
- Icelandic Stave
- Ruis

◊ The **New Moon** offers a blank slate. It is a period of new beginnings, abundant potential, and opportunities. It is the perfect time to set goals for the coming weeks, establish the steps needed to achieve your target, and determine how to reach them. Use the New Moon's energy in your journaling to help you set intentions and manifest your dreams.

◊ **Water** represents healing, intuition, and new beginnings. It has a life-giving force that invigorates, promoting emotional balance and restoring energy. Ritual baths are a powerful way to connect with water's energy. Add bay leaf and lavender to a bath during the New Moon to infuse your mind and body with their manifestation-promoting qualities.

◊ **Haglaz**, or Hagalaz, is the ninth rune in the Elder Futhark alphabet and translates as "hail." It represents a deviation from the expected, and new opportunities. When setting intentions during the New Moon, evaluate why they were chosen. Are they similar to past goals? Are your intentions based on something you have already accomplished? Are they challenging you? Consider trying a new direction, a different approach, and discover what you are truly capable of. Draw Haglaz on the bottom of your shoes to guide your journey in finding a new direction or different approach to your goals.

◊ **Polaris**, more commonly known as the North Star or Pole Star, is a symbol of guidance, direction, and stability. Known as one of the brightest stars in the Northern Hemisphere's night sky, Polaris, and all stars, represent infinite wonder and limitless possibilities. While it resembles a single star to the naked eye, Polaris is actually made up of three stars, and this is a reminder that although your path may appear differently to what you originally envisioned, it does not make your accomplishment any less wonderous.

◊ This **Icelandic Stave**, dated to the 16th century but recorded in the early 19th century in a Galdraskvæður (a grimoire, or book of magic), was created to be carried when facing or discovering the unknown. New beginnings, while exciting, can also be daunting. Should you feel anxious or uneasy, keep this stave with you as you begin to work on making your intentions a reality.

◊ **Ruis**, the fifteenth letter of the Ogham alphabet, represents the elder tree. Believed to keep evil spirits from entering the home in British folklore, elders symbolize beginnings and transformations. Incorporate Ruis into any magical practices or rituals performed during the New Moon phase to protect yourself and your intentions from negative energies.

Symbols for the Waxing Moon

- Fehu
- Tyr
- Waxing Crescent Moon
- Astraea
- Horse
- Herðslustafir

◊ The **Waxing Crescent Moon** phase of the lunar cycle is a time for growth and manifestation. In this period take the initial steps toward realizing the goals and intentions you set during the New Moon. The Waxing Moon encourages positivity and faith in your abilities, making it the perfect time for positive action and taking chances. Place a vessel of water near a window during this phase to allow it to absorb the Moon's energy. Whenever you struggle to remember your abilities, draw the symbol on your wrist, using the water.

◊ **Fehu**, the first rune in the Elder Futhark alphabet, is interpreted as cattle and wealth. A rune of luck, in divination Fehu represents success and foresight—helpful attributes for a Waxing Moon. Fehu also symbolizes new beginnings; it helps restore self-confidence and motivates us to take action rather than delay through apprehension and self-doubt. Write a list of hurdles you may face in the upcoming week. Carve Fehu into a green candle and, when lit, safely burn the list in the flame to dispel any obstacle to success.

◊ **Tyr** is a bind rune of stacked Tiwaz and Ansuz runes. Found on the Kylver stone, a runestone dated to about 400 CE from Gotland, Sweden, it is believed to have been created to call on Tyr and the Æsir for protection. Working toward a new goal may take you out of your comfort zone, to new opportunities and situations. Carry the Tyr stave as you approach these new experiences, to protect yourself and summon bravery, courage, and strength.

◊ **Astraea** is the Greek goddess of justice, innocence, and precision, who represents the goodness of the world. She is a symbol of hope eternal and the Greeks believed she would one day return to the world, bringing a golden age of harmony and peace with her. As you begin your path, use Astraea's symbol as a tool of encouragement. Approach each step with precision and hope, steadfastly moving closer to realizing your goals.

◊ **Horses** are strong, independent animals that are the embodiment of autonomy and confidence. They are beautiful, intelligent, and noble creatures. If you are feeling apprehensive or trapped and are struggling to motivate yourself, use this symbol created by the Mycenaean Greeks to imbue your daily life with the freedom and strength of a horse, and break free from your restraints. Push your limits and challenge yourself.

◊ **Herðslustafir** is an Icelandic stave. A pair of magical symbols created to bestow courage, it was recorded in a grimoire in the mid-19th century, but believed to have been in use since the 18th century. The grimoire directs the reader to carry the stave on the left-hand side of the chest and, as a result, the mind will be strengthened and impenetrable to any fear or dread. Carry the Herðslustafir with you—either drawn directly on your chest or on paper in your pocket—as you harness the energy of the Waxing Moon by moving beyond the confines of familiarity.

Symbols for the Full Moon

Lukkustafir

Full Moon

Gemini

Ansuz

Moon Gazing Hare

Mēness

◊ The **Full Moon** represents release and completion, a time for finishing tasks and identifying and shedding what no longer serves you. It is also a period of creativity and heightened emotions, the perfect time to seek endeavors that feed your creativity. Spend time creating artwork or crafts that incorporate the positive energy of the Full Moon to nurture your wellbeing and release negative energy.

◊ **Lukkustafir** is an Icelandic stave, recorded in the Galdrakver manuscript from the 19th century. The original manuscript includes the phrase "Fortune follow me, wherever I go" beside the stave, although others feature: "To prevent bad luck [and] comforts you; on sea and land, if you carry this stave with you." The Full Moon is a time for conclusions, settling outstanding tasks, and tying up loose ends before you begin on your next journey. Draw Lukkustafir on a coin and carry it with you as the Full Moon phase comes to an end to bring luck and fortune with you on the next stage of the cycle.

◊ **Gemini** is an astrological star sign that represents expressive and curious individuals. Geminis are imaginative and innovative, traits that complement the creative energy of the Full Moon. Geminis are also great communicators, able to identify aspects of their lives that are no longer serving them and can convey this clearly to others. During the Full Moon, trace the symbol for Gemini on your throat in water or perfume to promote the communication of your needs to others with clarity and purpose.

◊ **Ansuz**, the fourth rune in the Elder Futhark alphabet, is translated as "god." It is believed to have represented the Æsir, the gods of Germanic Paganism. In divination, Ansuz symbolizes communication, transformation, and inspiration, concepts in line with the positive energy of the Full Moon. During the Full Moon, carve Ansuz into a green candle and place it, unlit, in the window to absorb the Moon's energy. When next in need of powerful creative inspiration or divine support, light the candle.

◊ The **Moon Gazing Hare** is a mythical figure in many cultures throughout the world that dates to at least the 3rd century BCE. In ancient Egypt, it was believed that hares were linked with the Moon cycles, while the Germanic goddess Eostre was believed to transform into a hare during the Full Moon. In modern Paganism, the Moon Gazing Hare is a symbol of fertility, transformation, and growth. It is also a powerful symbol with centuries of belief woven into its image.

◊ **Mēness** is the Latvian god of the Moon. Sometimes depicted as a god of war and a soldier, his main role as a moon god symbolizes the processes and phases of life. Mēness represents all the periods of life—childhood, adolescence, and adulthood—as well as the cycle of beginning and completing activities or goals. Should you face difficulty in a phase of your life, or wish to seek inspiration for your next steps, use Moon water collected during a Full Moon to draw the symbol of Mēness on your skin.

Symbols for the Waning Moon

- Columba
- Thurisaz
- Waning Crescent Moon
- Libra
- Iron Nail
- Straif

◊ The **Waning Crescent Moon** phase is a period of rest and regeneration. It encourages you to practice self-care and reconnect with yourself, leaving behind anything out of your control before the Moon cycle begins again. The Waning Crescent provides healing energy, to release negative beliefs you hold about yourself. During this phase, reflect and endeavor to care for your own wellbeing. Place a candle on a windowsill in the moonlight overnight and light it when you require the Waning Moon's healing energy.

◊ **Columba** is a constellation visible from the Southern Hemisphere. It represents the dove, which symbolizes freedom, peace, and renewal. As this lunar cycle comes to an end, commit time to care for yourself, practicing self-care activities that revitalize and heal as you approach the next phase. Carve Columba's symbol into a bar of soap to infuse your body and mind with peace and kindness when used.

◊ **Thurisaz**, or Thurs, is the third rune in the Elder Futhark alphabet, and represents the forces of chaos that seek to disrupt your life. It also symbolizes defense and protection. These conflicting correspondences make Thurisaz a powerful rune to work with. If you are facing pressure, Thurisaz will help to rebound the negative energy, so you can relax and rest in the regenerative Waning Crescent phase. Infuse rosemary, basil, and mugwort in a carrier oil (safe for use on the skin) for an entire lunar cycle. Imbue yourself with protective energy by drawing the Thurisaz rune on your body with this oil before you shower or bathe.

◊ **Libra** is an astrological star sign representing balance, harmony, and peace. Typically keen to take an objective viewpoint, Librans are excellent analysts who dissect information. During the Waning Crescent phase, draw the sign of Libra on a piece of paper and, on the reverse, list the highs and lows of the past month. Roll the paper up and place it in a small container, alongside bloodstone and rose quartz, and seal it with wax. Carry the vessel throughout the next month to guide you in making well-informed, educated decisions on how to proceed, and release any lingering harmful energy or self-doubt.

◊ **Iron Nails** are historically seen as a symbol of protection. In the 1st century CE, Roman author Pliny the Elder advised nailing three into your doorway to protect your home. Iron nails are a powerful apotropaic symbol due to hundreds of years of collective belief in their protective influence. Tie an iron nail to a string and hang it in your home to protect you during the Waning Moon's time of healing and regeneration.

◊ **Straif**, the fourteenth letter of the Ogham alphabet, represents the blackthorn—a plant that produces white flowers among a bush of thorns. Although blackthorns are seen as a negative omen in Celtic mythology and symbolize the darker side of Witchcraft, they also signify personal growth and the cycle of life and death. Their imagery of white blooms amongst black thorns is a symbol of the strength and opportunity gained when faced with adversity.

Symbols for Special Occasions

Symbols for a Big Change

Delta

Amphitrite

Chalice

Aries

Raido

Úr

◊ **Amphitrite** is the Greek goddess of the sea, portrayed as the sea personified. According to *The Odyssey*, Amphitrite created sea creatures and all waves belonged to her. You are, much like Amphitrite, capable of great changes and vast depths; when a tidal wave threatens to knock you down, remember that you hold the power to create calm seas. Trace Amphitrite in a bowl of water filled with rose petals and violets. Carry a small jar of it with you as you approach a big change in your life.

◊ **Delta**, the fourth letter of the Greek alphabet, signifies the concept of change in mathematics. The triangle shape of the Delta represents a personal journey, symbolizing the constant evolution and fluctuations of life. Place this symbol somewhere you will see it regularly to remind yourself that even if an unexpected turn emerges on your path, it does not mean your journey is at an end—it's just taking a different direction.

◊ **Chalices** hold much symbolism. In Christianity, they represent redemption and honor; for Russian nobility, they denote splendor and prestige; in tarot, they pertain to emotional situations and events. Big changes are not always tangible, and emotional upheaval can often be difficult to circumvent. The Suit of Chalices, or Cups, in tarot is connected to soul relationships and matters, and asks you to pay attention to your intuition, dreams, and emotions. When facing a big change, embroider the symbol into your clothes, ensuring you listen to your heart and your head.

◊ **Aries** is an astrological star sign that thrives on competition and challenges. Aries are successful leaders, unstoppable in the face of adversity. As a fire sign, Aries are passionate and motivated, unafraid to be the first to attempt something and inspire others. Draw the symbol for Aries on a piece of paper and safely burn it to support you in channeling Aries's daring character as you approach the unknown, being inspired by their bold and courageous energy.

◊ **Raido**, also known as Reid, is the fifth letter in the Elder Futhark alphabet. It represents "ride" or "journey," and is associated with the journey of life. In divination, Raido relates to being in control and taking charge of your future, and choosing the right path and being confident in your decisions. If you feel anxious about a decision, take a moment to breathe deeply while tracing Raido on the palm of your hand. Raido reminds you to be responsible for your own life, making decisions and big changes for your benefit rather than for others.

◊ **Úr** is the eighteenth symbol in the Ogham alphabet, and represents the clay, earth, and soil. This is a grounding symbol, bringing you back to the roots of yourself. Úr is also connected to heather—a plant associated with healing and homelands, and burned to protect folks from evil spirits. If you feel like you're being swept away during a big change, draw on Úr's grounding and protective energy to find your feet. Place a piece of paper bearing the symbol in the soles of your shoe to keep you grounded.

Symbols for a New Baby

- Acorn
- Hebe
- Alpha
- Feingur
- Luckenbooth
- Gort

◊ **Hebe** is the Greek goddess of youth and exudes childish joy and a love for life. Although often connected with marriage, Hebe also represents the prime of life, or the best years of one's life. Welcoming a new baby is a joyful time but can be incredibly challenging and isolating, making it difficult to take time to appreciate the small pleasures. Keep an image of Hebe somewhere you will see it regularly during sleepless nights, as a reminder to appreciate the moments of pure love and carry them in your heart.

◊ **Acorns** are symbols of fertility, growth, and new life. Though small and unassuming, they hold great potential. As a 14th-century English proverb attests, "mighty oaks from tiny acorns grow." In northern European Celtic mythology, acorns were seen as a powerful talisman for good luck and prosperity. Hold an acorn and share with it your hopes and dreams for the future; place it in a high place in your new baby's room to share its powerful energy with your child.

◊ **Alpha**, the first letter in the Greek alphabet, represents beginnings: the start of your child's life, the commencement of your journey as a parent, and the path you will both take going forward. Life is full of beginnings—first words, the first wobbly steps, the first laugh. Place Alpha in a place you regularly pass in your home as a reminder to stop for a moment and appreciate your child's "firsts," as well as your own as a parent.

◊ **Feingur** is an Icelandic stave created to ensure fertility, easy birth, and healthy children. Originally designed to be etched into a piece of cheese and then eaten by the person who wished to be with child, this symbol could also be tattooed or drawn on the skin. While Feingur may not guarantee fertility and an easy birth, it can assist with anxieties surrounding pregnancy and labor. If you are hoping for a pregnancy, or are soon to give birth, trace Feingur in the air using incense as a way of clearing your space of anxiety and channeling your fears when they become overwhelming and need to be released.

◊ **Luckenbooths** are a heart-shaped symbol, often displayed on brooches and traditionally given to new mothers to support breastfeeding. They also act as an apotropaic symbol to protect both mother and child. They were created in Scotland in the 16th century. Wear this symbol to protect you and your child from negative energy, and to support you both as you find your footing as a new parent.

◊ **Gort**, the twelfth letter in the Ogham alphabet, is translated as "field" and represents the ivy plant. Although ivy is often associated with ruin and destruction, rooting itself into walls, it is also incredibly powerful. Its deep roots symbolize growth and fertility. Create a talisman bearing Gort, such as carved onto wood or fashioned by clay and carry it with you for strength and protection, and as a reminder of your growth and resilience.

Symbols for Special Occasions

Earth
(Horseshoe)

Earth
(Astronomical)

Othala

Symbols for
a New Home

Cauldron

Vesta

Māra's Cross

◊ **Horseshoes** are a popular symbol of good luck. Between the 11th and 14th centuries CE, horseshoes began to be used as protective talismans and were nailed above the thresholds of homes. The placement of the horseshoe was important—if the prongs were pointed upward it was believed the luck would be held within and never run out, whereas prongs pointed downward would ensure good luck was diffused into the home. Place a horseshoe above your front door to gather good luck that will spread throughout your new home.

◊ **Earth (Astronomical)**, the third planet from the Sun, represents home and our place of origin. Earth's symbol denotes our connection with our planet—a deep, interconnected and reverent relationship. Place the Earth symbol in your home to give thanks to the planet and all it offers you and as a reminder to treat it with the respect and admiration it deserves.

◊ **Othala**, also known as Otila and Odal, represents property, ancestors, and heritage. The twenty-fourth rune in the Elder Futhark alphabet, it symbolizes the importance of learning about those who lived on the land before us: including those who cultivated it, created families there, or those it was stolen from. It should be noted that this rune was co-opted by the Nazi party in the late 1930s as a symbol of racial purity. While this does not bar the usage of the rune, its use should always be interpreted in conjunction with its context.

◊ **Cauldron** symbols feature on a number of Pictish standing stones in western Scotland. Cauldrons have a host of symbolism attached to them. They are used in modern Witchcraft as a symbol of the creative forces of transformation. At their heart, however, they are a domestic item. Cauldrons are a reminder that there is magic in the mundane, in the cooking of food, in the laundering of clothes, and in the heating of your home. Keep this symbol in the areas of your home where these tasks are completed, to introduce a bit of magic into your everyday.

◊ **Vesta** is the Roman goddess of the hearth, home, and family. Often represented as a sacred flame that was the root of life in the community, she ensured the protection of Rome, its population, and its agricultural bounty. Carve Vesta's symbol into a candle and light it within your home to protect those within.

◊ **Māra's Cross** is the symbol of Māra, the Latvian goddess of all economic activities and the land. She is the patroness of what were considered feminine duties—grinding grain, milking cows, and tending to the home. Māra was the protector of the home and all who dwelled within. Her cross was traditionally scoured onto loaves of bread or above fireplaces as a mark of gratitude and protection. To protect your new home from negative energy, draw Māra's Cross in oil while cooking, carve it into the soil of your garden, and place it above your hearth or kitchen.

Symbols for Birthdays

Triglav

Gēr

Lily of the Valley

Austra's Koks

Arrow

Triquetra

◊ **Gēr**, or gær, is a rune from the Anglo-Frisian alphabet. It represents "year" and "harvest," and is often interpreted in divination as prosperity. Gēr inspires you to be grateful for the gifts you receive, the opportunities you sow, and the success you reap. Birthdays are a time for celebration and reflection. Ask yourself: What have I achieved this past year? How have I grown? What do I wish to achieve in the coming year? Write your reflections on paper burn it with rosemary safely in a cauldron. With the cooled ashes, draw the Gēr rune and keep it in your purse or wallet to attract prosperity for the next year.

◊ **Triglav** is a three-headed figure from Slavic Pagan mythology. Believed to have combined the three gods of Earth, Heaven, and the Underworld, Triglav represents the different facets of the passing of time: the essence of youth and promise of growth, strength, courage, and wisdom. The three gods symbolized the cyclical nature of life, the changing seasons, and the different periods of life. Rather than viewing ageing negatively, Triglav guides you to appreciate the new experiences you encounter and the wisdom you uncover as you grow older.

◊ **Lily of the Valley** is a flower that blooms toward the end of spring, signifying the beginning of summer. It symbolizes youth, joy, and happiness. Gifting lily of the valley as a symbol of luck and happiness is a traditional French custom. Gift lily of the valley to a loved one on their birthday, or place them in your home, to ensure happiness and joy for the upcoming year.

◊ **Austra's Koks** is a traditional Latvian symbol for Austra, the goddess of the dawn. Austra's Koks represents the daily path of the Sun and its connection to our changing seasons. It is used as an apotropaic symbol to protect that which is valuable, and as a talisman for luck and success. Draw this symbol on your window on your birthday so it can catch the first rays of the dawn Sun; ensure you trace over it regularly to bring success to the next year.

◊ The **Triquetra** symbol represents the cycle of life. Found in northern European art from the 4th century BCE, it has a long history of use and continues to be a popular symbol in modern Witchcraft as a sign of the Triple Goddess, a deity that represents the cycle of birth, life, and death, and the Irish goddess Morrigan. It is a powerful symbol, also used for apotropaic purposes. Carry it throughout the year to protect yourself from harmful energies and negative thoughts.

◊ **Arrows** are typically used to indicate a direction, and a path you should follow. While they are tools for hunting and protection, they also represent the physical act of moving forward. As an arrow can only be shot forward with momentum by pulling backward, it symbolizes triumph after being tugged back by struggle. As your next year begins, trace an arrow symbol in a bath scented with lemon balm and calendula to aid you in shedding yourself of anything that is pulling you backward, so that you are shooting forward toward your goal.

Symbols for Career Goals

First Quarter Moon

Gold

Tiwaz

Scorpio

Krupitis

Lead

◇ **Gold** has a long history of being connected with luxury and wealth. However, gold also denotes generosity and compassion. In alchemy, gold was the ultimate goal: the perfection of all matter, including the mind, spirit, and soul. What is the ultimate goal for your career? What do you hope to achieve? Keep this symbol with you at work as a reminder of your goal, giving you the drive to achieve your career dreams while remaining compassionate and generous to others.

◇ The **First Quarter Moon** is a time for action, decisions, and commitment. It encourages us to reassess where we stand, make adjustments, and move forward with purpose. Place a drawing of the First Quarter Moon behind your work ID card to ensure you do not lose sight of your career goals while also being reflexive; learn from your mistakes, celebrate your achievements, and continue on your journey with renewed determination.

◇ **Tiwaz** is the seventeenth rune in the Elder Futhark alphabet and represents Týr. The god of war, heroism, and justice, Týr was seen as the head of the Germanic pantheon. He was brave and renowned for upholding oaths and for his loyalty to others. Soldiers carved Tiwaz into their blades before battle to ensure their victory. The politics of the workplace can often feel like a battleground. Carve or draw Tiwaz onto your "sword"—keyboard—at work to ensure victory in the face of adversity.

◇ **Scorpio** is an astrological star sign that represents a determined, ambitious, and passionate individual. Scorpios are independent and charismatic, but also relentlessly loyal and persistently curious. They are born to succeed and excel, drawn to education and mastering whatever they turn their hand to. Trace the symbol for Scorpio while stirring in your morning tea or coffee; it will support you in balancing independence and charisma with a love for learning and personal development.

◇ **Krupitis** is the symbol of wisdom and knowledge in Latvian folklore. It represents the balance between the world of dreams and desires, highlighting the difference between what is achievable and what should remain a dream. Keep the Krupitis symbol nearby when working to ensure you do not take on more than you can manage, leading to burnout.

◇ **Lead** is a soft and malleable heavy metal. In alchemy, it represents protection, stability, and self-control, and was associated with spiritual development as well as transformation. Lead is also connected to Saturn, the planet of discipline and ambition. Although related to hard work through its bond with Saturn, lead's steadfast and apotropaic character in alchemy is a reminder that one should not exist without the other. While hard work can pay off in your career, endeavor to protect yourself and your wellbeing at the same time.

Symbols for Graduation

Perthro

Bee

Fortuna

Uranus

Hercules

Sigma

◊ **Fortuna** is the Roman goddess of fortune and fate, and the personification of luck. She is often depicted holding a cornucopia from where plenty flows, a globe symbolizing chance, a rudder to steer fate, and a wheel of fortune to represent luck. Carve this symbol into a green candle and then place it among coins and rosemary. Light the candle to ask for good fortune and luck from Fortuna in your graduation and journey beyond education.

◊ **Perthro**, also known as Peorð, is the fourteenth rune in the Elder Futhark alphabet. Its original meaning is now lost but in divination it is a good omen, representing good luck, joy, and change. When Perthro is cast it indicates favorable circumstances are approaching, resulting in good fortune and reaching your goals. Ensure you hold the symbol of Perthro close as you complete your exams and coursework, and enter the next stage of your life after graduation to ensure favourable circumstances and success.

◊ **Bees** are hard-working. Throughout history, they have symbolized focus, dedication, and productivity. However, bees also represent the importance of teamwork and community. This sense of kinship isn't just for the colony themselves; in British folklore, telling the bees of important events in the family was vital to keeping them content. As you graduate and dedicate yourself to a new venture, remember to turn to your loved ones for support and keep them abreast of events.

◊ **Uranus**, the seventh planet from the Sun, represents upheaval and breakthroughs. It has an erratic, rebellious nature that lends itself to ingenuity and revolution. As you approach a new stage of your life, Uranus encourages you to march to the beat of your own drum and set your own path. Carve Uranus's symbol into a gold or yellow candle and light it during the Waxing Moon phase; it will guide you toward the path that serves your true self.

◊ **Hercules** is a Roman hero known for his physical power and adventures. Over his life, Hercules and his Greek counterpart Heracles overcame numerous obstacles using their strength and wisdom. Life after graduation will contain unknown challenges and hurdles. Like Hercules and Heracles, use both the knowledge and tenacity you've acquired during the trials and tribulations of your education to approach them and emerge victorious. Draw this symbol on a closed padlock to lock in your focus and perseverance while studying.

◊ **Sigma** is the eighteenth letter in the Greek alphabet. In mathematics, it represents the sum of all. Graduation is the cumulative response to years of hard work, and a time to look back and feel pride in your accomplishments. It can be easy to get lost in the relief of graduating and the anxiety about what is to come. Trace Sigma in the air using cedar or lemon balm incense and create a list of your successes and the obstacles you have overcome to remind yourself of your tenacity and strength. Look back on it in difficult times as a reminder of your successes.

Symbols for Journeys

Lupus Mettalorum

Sagittarius

Upsilon

Sailor's Knot

Sator Square

Coll

◊ **Lupus Mettalorum**, also known as "grey wolf", was an important element in the alchemical process. It was used to purify alloyed metals into pure gold, although this was not always effective. Lupus Mettalorum represents the turning point of the alchemical process, the fork in the road that could lead to either success or failure. When planning a journey, keep the symbol for Lupus Mettalorum nearby as a reminder to take your time to consider your path, weighing up the options and assessing each choice to ensure success.

◊ **Sagittarius** is an astrological star sign that represents a lively individual who love freedom. Saggittarians are born travelers, explorers, and adventurers, and are not keen on restraints and schedules. Journeys can be nerve-wracking, especially if traveling alone. Carve Sagittarius's symbol into a red candle and set it alight before the start of your journey to channel this sign's outgoing nature. Keep the wax stub in your pocket as you travel to carry this energy with you.

◊ **Upsilon** is the twentieth letter in the Greek alphabet. Pythagoras used Upsilon as a symbol of the path of virtue, the place where your journey divides into two parts and you must make a choice of which route to take. Journeys are not just physical; they can also be related to the spiritual or mental. If you are at a fork in the road and are unsure of which path is the best for you, place the Upsilon symbol under your pillow to receive enlightenment.

◊ **Sailor's Knots** originate from ancient Celtic communities in Ireland. They were carried by sailors on long journeys as a token of love. Sailor's Knots are made of two intertwined ropes, symbolizing harmony, friendship, and deep love. Carry a Celtic Sailor's Knot on your journey as a reminder of those you love who await your return.

◊ **Sator Squares** feature in numerous cultures and civilizations over the centuries. The earliest was uncovered in the remains of Pompeii, which was buried in 79 CE, while other versions have been found dating from the 3rd century in Syria, the 9th century in France, and the 14th century in Sweden. The Sator Square is an acrostic word square, believed to have originated as a word puzzle in ancient Rome. In medieval Britain, the symbol was used as a good luck charm, engraved into buildings and amulets to bring fortune. Paint the Sator Square on a large, flat shell and carry it with you as a talisman of good luck on your journeys.

◊ **Coll** is the ninth letter of the Ogham alphabet, representing the hazel tree. In the British Isles, carrying a hazel rod is believed to offer protection against evil spirits, while hazelnuts were traditionally carried as apotropaic charms. In Ireland, hazel was known to bestow wisdom as the Tree of Knowledge. If carrying a staff made of hazel may be difficult on your journey, stitch the symbol of Coll into your bag to protect yourself from negative energies and harmful situations.

Symbols for Marriage

Živa

Greek Key

Gebô

Ivy Leaf

Bowen Knot

Juno

◇ The **Greek Key**, also known as a meander key, is a common symbol in ancient Greek art. Commonly used as a decorative border, it is constructed from a continuous line shaped into a repeated pattern. It symbolizes unity, infinity, and the eternal flow of life. The Greek Key also represents the bonds of friendship, love, and devotion. Draw the Greek Key around your vows to reinforce them with these amorous attributes.

◇ **Živa** is the mother goddess of the Obodritic, a western Slavic tribe. The goddess of marriage, love, and fertility, she offers protection and nurturing energy. Živa represents our own divine being, providing the strength and knowledge to appreciate all of life and teaching you to find good in even the worst experiences. Keep Živa's symbol in a visible place in your home as a reminder to seek light in the darkness during challenging times.

◇ **Gebô**, also known as Gyfu or Gifu, is the seventh rune of the Elder Futhark alphabet and translates directly as "gift." In divination, Gebô represents generosity, honor, and the giving and receiving relationship in friendships and romantic partnerships. This rune highlights the many facets of gifts—they are not just material items, but include the gifts of time, attention, and love. Gebô encourages us to give ourselves wholly to our partners, unselfishly gifting them both our body and mind as an act of love.

◇ **Ivy Leaves** represent everlasting life, fidelity, and loyalty. In ancient Greece, ivy was presented to newly married couples as a symbol of devotion. Aspects of this symbolism were adopted in early Christianity, where ivy leaves were used to denote deep, enduring love and friendship. It was common in British folk tradition to include ivy in the bridal bouquet, a practice that continues today. Include ivy leaves, either foliage or the symbol itself, in your wedding decor to symbolize your ardent love for each other.

◇ **Bowen Knots** symbolize infinity, love, and protection. It is also known as a form of shield knot and some historians theorize its use was established in ancient Mesopotamia. Bowen Knots are prevalent throughout the world; they were used as apotropaic marks in Finland, have been uncovered on standing stones from 5th-century Sweden, and remain a popular symbol in modern Witchcraft. Carve a Bowen Knot symbol into wood or clay and hang it at the entrance to your home to protect your marriage from the negative energy of others who wish you harm.

◇ **Juno** is a Roman deity, known as the goddess of marriage and community prosperity. She represents marital harmony and protection, and the ongoing fortune of the family. Following your marriage, place this symbol in the room of your shared home that you both spend the most time in to reinforce the emotional bonds of your partnership, and to celebrate a happy, successful union.

Symbols for Careers

Symbols for Technology

Capricorn

Yr

Key

Mercury

Huginn and Muninn

Double Spiral

◇ **Yr** represents a bow, used for directing and firing arrows toward a target. The twenty-seventh rune of the Anglo-Frisian alphabet, it symbolizes self-improvement, since a bow requires dedication and tenacity to master. Your capabilities need to constantly evolve to meet the ever-changing demands of a technological career. When learning a new ability, draw Yr on the tools of your work—such as a mouse or keyboard—to assist you in mastering your new skill.

◇ **Capricorn** is an astrological star sign that is disciplined and resourceful. Capricorns are hardworking individuals who are confident in their skills and abilities, and relentless and determined to overcome any obstacles. When taking on a big project or working to a tight deadline, keep the symbol for Capricorn nearby to channel the sign's tenacious energy. But be careful; Capricorns are also self-critical. While being reflexive is not always a negative trait, ensure you are not being overly harsh on yourself and see any mistakes made as a learning experience rather than a failure.

◇ **Keys** are a popular symbol in Witchcraft. They represent the opening of doors and freedom, helping us to unlock knowledge and protect that which we hold dear. When learning a new skill—or trying to solve a difficult problem—wear a key around your neck, or place it in a visible place on your desk, to assist you in revealing knowledge and a greater understanding of the information.

◇ **Mercury** is the first planet from the Sun and the smallest planet in our solar system. It is named after the Roman god of commerce, luck, and communication, who was also the messenger of the gods. Mercury is the ruling planet of Gemini and Virgo, star signs with strong communication skills. If you are struggling to communicate your needs and ideas—or colleagues are not listening—keep this symbol behind your ID card or in your pocket to keep dialogue open and flowing.

◇ **Huginn and Muninn** are a pair of ravens, messengers to the Norse god Odin. They represent duality and the concept of holding two parts, often in opposition to each other, like good and evil or life and death. In Norse myths, Huginn and Muninn symbolize memory and thought and are the embodiment of intellectual pursuits. Wear the symbol of Huginn and Muninn close to your heart to encourage you to go further than memorizing details, instead using your mind to apply concepts to your own experiences and actions.

◇ The **Double Spiral** signifies the importance of balancing two opposing forces. It is a reminder that everything holds an opposite. Balance in your life, especially when working within a mentally demanding profession like technology, is difficult to achieve. Keep this symbol as your desktop background to act as a constant reminder to impose boundaries and stop your work from filtering into your personal time. Allow yourself to rest, recover, and, in time, thrive.

Symbols for Public Services

Third Quarter Moon

Gar

Icelandic Stave

Four-Leaf Clover

Tinne

Rowan

◊ **Gar** is an Anglo-Frisian rune, interpreted as "spear." Spears represent strength and power and are predominately weapons, initially used for long-distance throwing and later in formation with others in close combat. They are a tool that is effective when working alone or as part of a group—skills that are vital when working in public services. Carry the Gar rune with you at work—such as in your ID badge or pocket—to reinforce your ability to work well by yourself and with your colleagues.

◊ The **Third Quarter Moon** phase, the stage before the Waxing Crescent occurs, is a time to free yourself of past struggles and move forward with a clean slate. During this period do not try anything new, but focus instead on letting go of negativity and practicing self-care. Public service jobs are rewarding but also demanding and require a lot of your physical and mental energy. Use this symbol as a reminder to care for yourself to avoid burnout in your career.

◊ This **Icelandic Stave** was recorded in the Galdraskvæður in the 19th century but its use dates to the early 16th century. It was created to empower the holder to win debates, bestowing on them the power of communication, persuasion, and conviction. If you need someone to listen—whether a colleague, a student, or a boss—draw this stave on your inner left wrist to ensure your case is heard and taken on board.

◊ **Four-Leaf Clovers** are a rare variant of the common three-leaf clover, and their connection to good luck was first recorded in the early 17th century. Though it is believed to have been a common folk belief for hundreds of years prior. Trace this symbol while stirring your morning cup of tea or coffee to imbue it with good fortune. In a role that requires hard work, determination, and empathy, a little extra luck cannot go amiss.

◊ **Tinne** is the eighth letter in the Ogham alphabet and translates as "ingot" or "iron bar." Iron is a strong metal, representing fortitude, tenacity, and valor—attributes necessary when working in public services. Tinne also corresponds to holly, a tree associated with empathy, another valuable trait when serving others in your career. Tinne is the perfect symbol for those in public service since it provides courage in the face of adversity and supports compassionate actions; should you find yourself approaching a difficult situation, trace this symbol on your inner wrists to aid your work.

◊ **Rowan** trees symbolize courage, wisdom, and protection. In English folklore, it was traditional to plant a rowan tree beside the home to protect those within. In a career in which helping others is important, carry a rowan leaf (either the plant or a drawing) with you to protect yourself and those you seek to assist from harm and negative energy.

Symbols for Customer Services

Radegast

Solomon's Knot

Honey

Kaupaloki

Perseus

Hexahedron

◊ **Solomon's Knot**, also known as the Pelta Cross, is an apotropaic symbol offering protection. It dates to at least the Neolithic (or Stone) Age and appears in Roman mosaics from the 4th century, in the illustrations in 14th-century Quar'ans, and carvings in the stone walls of 16th-century churches in England. It has a long history of offering protection, with some believing it could trap evil entities within its twists and turns. Carry Solomon's Knot with you at work—drawn on paper tucked into your pocket or on your skin—to protect yourself from the negative energies of others.

◊ **Radegast** is the Slavic Pagan god of crops, abundance, and hospitality. Known for his joy of food and drink, Radegast would richly reward hospitality shown to him. Radegast's symbol encourages us to be gracious and courteous to customers, offering unparalleled hospitality. However, Radegast also represents the Sun and fire. Although going above and beyond for customers is a worthy endeavor, ensure you are not allowing your own fire to burn out in the process.

◊ **Honey** has played an important role in human civilization for centuries. It represents sweetness, abundance, and knowledge. Draw this symbol—used by the Mycenaean Greek civilization as part of the Linear B alphabet—where you will easily see it while dealing with customers, such as by the till, as your desktop background, or next to your work phone. It will add a touch of honey's sweetness to your discussions, making it easier to manage challenging customers.

◊ **Kaupaloki** is an Icelandic stave created to provide prosperity in trade or business. Recorded in a 19th-century manuscript, it is most effective when carved into a tablet of beechwood and carried on your breast. If a beech tablet is difficult to come by, paint the stave onto a piece of wood found in your backyard or the forest and carry it by your heart to ensure success in your business.

◊ **Perseus** is a legendary hero in Greek mythology, known for overcoming obstacles and defeating monsters. You will come across many obstacles within customer services—managing tight deadlines, handling busy periods, and working long shifts—and many monsters in the form of challenging staff or belligerent customers. Draw the symbol for Perseus on a small piece of paper and place it inside a container, alongside dried ginger and basil. Seal it with wax and carry it with you during your work to channel his bravery and empower you to hold your ground when faced with an abundance of tasks or customers.

◊ The **Hexahedron** in sacred geometry symbolizes the earth, one of the building blocks of life. It is connected to the root chakra, which represents stability and support. Working in customer services is both mentally and physically exhausting and can lead to frustration, anger, and anxiety in periods of high stress. When it all feels too much, remember to ground yourself. Take a few minutes out of your work day and take a deep breath as you visualize the hexahedron, slowly rotating.

Symbols for Creatives

Wool

Pisces

Onn

Witch's Knot

Bell

Pax Cultura

◊ **Pisces** is an astrological star sign that represents a highly creative individual. Compassionate and deeply imaginative, Pisces are drawn to self-expression through artistic endeavors. Ruled by Jupiter, the planet of opportunity and luck, and the innovative and mystical planet Neptune, Pisces are spurred on in artistic pursuits by finding magic in their everyday lives. When experiencing a creative block, draw this symbol on a piece of paper and place it under your pillow to help break down any hurdles, opening your eyes to inspiration wherever you look.

◊ **Wool** is a symbol of renewal, comfort, and growth. Associated with the earth element, it connects your artistic side with the natural world and grounds you in the beauty and magic of nature. Wool is heavily connected to creativity, playing a role in many crafts. While spending time in nature, trace this symbol—from the Linear B alphabet of the Mycenaean Greek civilization—into the earth. This will ground you when you are feeling overwhelmed. It will re-introduce you to the roots of your passion and renew your artistic spark.

◊ **Onn** symbolizes the ash tree, a dense, resilient hardwood. The seventeenth letter in the Ogham alphabet, Onn is also associated with quality craftwork. Working in a creative role requires a high level of tenacity and drive. You will encounter pitfalls, false starts, and negativity, but as long as you believe in yourself and your craft, you will succeed. Carve or draw Onn onto your tools—a paintbrush, a keyboard, a crochet hook—to imbue yourself with strength and determination as you work.

◊ The **Witch's Knot** is an apotropaic symbol representing balance and harmony. The earliest references to it are from 1644, although it is believed to have been used in folk practices for much longer, and it continues to be a popular symbol in modern Witchcraft. When you have finished your work for the day, trace the Witch's Knot in the air using rosemary or cinnamon incense to protect your personal time outside of your work. It can be easy for a job you have a passion for to slowly take over your life, but balance and harmony will help to prevent burnout.

◊ **Bells** represent beginnings and endings and are a call to order. Their sounds are a symbol of creative power and banish negative influences, protecting you from the harmful opinions of others or yourself. When that voice of self-doubt rises, or you give more credence to others' judgments than they deserve, ring a bell to dispel the negativity and reset your thoughts.

◊ The **Pax Cultura** symbol represents the value of defending symbols and areas of cultural significance during war. Formulated in 1899 by Russian artist Nicholas Roerich, the Pax Cultura movement was integral in the aftermath of World War II when new international laws regarding the protection of cultural heritage were created. Pax Cultura, translated as "peace through culture," continues to work toward the preservation of heritage and art. The symbol originates from an amulet dating to the Neolithic (or Stone) Age in northern France and has come to represent the importance of art, and our right to create it, for humanity.

Practical Sigils

Practical Sigils

History of Sigils

Sigils are a type of symbol used in magical practices. They are, in their basest form, symbols created to hold magical power. As such, sigils have likely been used for centuries, as many civilizations have examples of magical symbols. In the Neolithic period, artifacts with spiritual significance, such as wheel-shaped talismans from western Pakistan, have been excavated, while ancient Greeks carried *periapta* (amulets) inscribed with incantations and Romans wore amulets from the 4th to 7th centuries to protect from sickness.

In the European Middle Ages—6th to 16th centuries CE—sigils began to resemble the versions familiar to us today. They were used extensively by occultists in magical practices. During the 16th century, occultism and Christianity became intertwined. Grimoires featuring saints connected with positive supernatural powers were published, such as *The Lesser Key of Solomon*, which contained seventy-two sigils, each representing an entity in the hierarchy of hell. Some occultists also provided instructions to create your own sigils, as found, for example, in Henry Cornelius Agrippa's book *Occult Philosophy*, although this was centered around the power of saints and planetary forces.

Sigils in the Modern Era

During the 20th century, Austin Osman Spare, an English occultist and artist, wrote a series of grimoires and created a practical guide to crafting your own sigils. This remains one of the most popular ways to create sigils in modern-day Witchcraft and magical practice.

Ready-made sigils can be found throughout the internet and in books, but you can also craft your own that are deeply personal and imbued with magical intentions.

Crafting Your Own Sigils

Austin Osman Spare's Version

Step 1: Define your intention

Sigils are visual interpretations of an intention or desire. Decide what you would like your sigil to represent or attract and write it down as a statement in capital letters.

For example:

I WILL RECEIVE A PROMOTION

Step 2: Remove any repeating letters or vowels from your statement

For example:

I̶ W̶I̶L̶L̶ R̶E̶C̶E̶I̶V̶E̶ A̶ P̶R̶O̶M̶O̶T̶I̶O̶N̶

This leaves you with the following letters:

W L R C V P M T N

Step 3: Create the sigil

The sigil is created with the letters above, arranged in any way you prefer. Letters can be mirrored or upside down, arranged in a circle, or even placed within a grid. Try not to feel disappointed if you aren't happy with your first attempt—it can take some time and practice to create a sigil you wish to use.

The more you do it the easier it becomes.

For example:

Step 4: Charge your sigil

Charging your sigil will give its power a boost and strengthen its manifesting capabilities. You can do it in several ways: meditate on the image, focusing on your intention; surround it with crystals that hold relevant properties, such as rose quartz for love or sodalite for focus; draw the sigil on paper and then burn it; trace it in soil or water; place it in the moonlight to absorb the Moon's energy; draw a circle in the air around it with lit incense.

There is no correct way to charge a sigil. Choose whichever way feels best for you. Remember to regularly charge your sigil—infusing it with energy to intensify its properties—to ensure it retains magical power. This can be done by placing the sigil in sun or moonlight, focusing your intentions on it, or surrounding it with crystals that carry similar intentions.

Using a Sigil Wheel

Step 1: Decide what you would like your sigil to represent or attract and simplify it down to one word

For example:
I WILL RECEIVE A PROMOTION

will become: **PROMOTION**

Step 2: Remove any repeating letters from your word

For example:
PROMØTIØN

This leaves you with the following letters:
PROMTIN

Step 3: Draw a sigil wheel

It does not have to be an exact copy of the below, but it should contain three inner wheels with the letters of the alphabet inside. If you wish to, other alphabets such as Greek can be used.

Step 4: Trace your word

Either drawing directly onto the wheel, or using tracing paper layered over the top of the wheel, connect the letters from your word using lines until you've spelled out your chosen word.

Step 5: Charge your sigil

Imbue your sigil with intention. Meditate on the image, draw it on paper, and then burn it or trace it in water—whichever way feels right to you.

The shape you created will be your sigil. It can be stylized by curving lines, adding an outer circle, or with dots and lines.

Practical Sigils ♦♦♦ 127

Using a Magic Square

Step 1: Define your intention and simplify it down to one word

For example:

I WILL RECEIVE A PROMOTION

will become: **PROMOTION**

Step 2: Remove any repeating letters from your word

For example:

PROMØTIØN

This leaves you with the following letters:

PROMTIN

Step 3: Draw a magic square

Some sigil creators use different-sized magic squares based on planetary energy, just as magical practitioners did in the Middle Ages.

For example, Saturn is represented by the number 3, so the magic square will be three squares by three squares, creating nine squares total.

Draw the numbers 1 to 9 in the boxes. This can be in order, random, or by ensuring each line adds up to the same number.

In this example, each line has a sum of 15:

4	9	2
3	5	7
8	1	6

For the magic square associated with Jupiter, you need four squares by four squares, In this version, each row, column, and diagonal adds up to 34:

This is a Mars magic square. It is a five by five magic square, and each row, column, and diagonal adds up to 65:

4	14	15	1
9	7	6	12
5	11	10	8
16	2	3	13

11	24	7	20	3
4	12	25	8	16
17	5	13	21	9
10	18	1	14	22
23	6	19	2	15

Step 4: Assign letters

Designate letters of the alphabet to the numbers 1 to 9, 16, or 25, depending on which square you have chosen.

1	2	3	4	5	6	7	8	9
A	B	C	D	E	F	G	H	I
J	K	L	M	N	O	P	Q	R
S	T	U	V	W	X	Y	Z	

Practical Sigils

Step 5: Map your intention

Using the word you set earlier, identify the numbers identified to each letter. If a number appears more than once, remove any additional instances.

P	R	O	M	T	I	N
7	9	6	4	2	~~0~~	5

Step 6: Trace your sigil

Map these numbers on the magic square using a continuous line.

As with the sigil created using a sigil wheel, the shape you created can be further stylized to suit your taste.

Or you may like to curve the lines like this:

Step 7: Charge your sigil

Charge your sigil to strengthen its power. This can be done in several ways, such as placing it in moonlight or surrounding it with intention-boosting crystals, and will bolster its manifesting capabilities.

Examples of sigils:

Tranquil

Tenacity

Focus

Serene

Be creative in how you use symbols!

Conclusion

Magical practitioners find inspiration in the world around them. We can see magic in the shape of a leaf, in the history of a rune, and in the creation of a sigil.

As you delve into the word of magical symbols and sigils, remember these three key pieces of practical advice:

1. DO YOUR RESEARCH! Find out as much information as you can about the symbol, reading about where it came from, who used it, and if its meaning has ever changed. Gathering knowledge helps you to make informed decisions and strengthens your practice.

2. USE YOUR INTUITION. If you cannot find any reason for why you want to use a specific symbol in your practice but feel drawn to it, go with it—your intuition is calling you to incorporate it into your craft.

3. HAVE A GOOD TIME. Be creative in how you use symbols! Do not feel limited and find new ways to include the symbols in your everyday life.

I hope you enjoyed this book and that it brought you closer to symbols you use in your practice, as well as introducing you to several new ones along the way.

REMEMBER: Symbols can be found anywhere, and we are the ones who imbue them with magic and power by discovering their history and instilling them with intention. We weave together our ideas, beliefs, and energy with the historical power of symbols to create deeper meaning in our rituals and practices.

Recommended Reading

RECOMMENDED READING

When researching magical symbols, focus on books, articles, and websites that can provide additional references to assist you in furthering your study and verifying the information they have provided.

The books listed below largely cover the periods, areas, and symbols mentioned within *Practical Symbols*. If you wish to research symbols outside of the cultures within this book, search for indigenous authors who can provide expert knowledge and information.

HISTORY

The Oxford Illustrated History of Witchcraft and Magic edited by Owen Davies (2021)

Magical House Protection: The Archaeology of Counter-Witchcraft by Brian Hoggard (2019)

Archaeology and Folklore edited by Amy Gazin-Schwartz & Cornelius J. Holtorf (1999)

Pagan Religions of the Ancient British Isles: Their Nature and Legacy by Ronald Hutton (2010)

The Archaeology of Ritual and Magic by Ralph Merrifield (1988)

Cunning Folk: Life in the Era of Practical Magic by Tabitha Stanmore (2024)

SYMBOLS

Runes: A Handbook by Michael P. Barnes (2012)

Symbols of the Occult: A Directory of over 500 Signs, Symbols and Icons by Eric Chaline (2021)

The Penguin Dictionary of Symbols by Alain Gheerbrant, Jean Chevalier and John Buchanan-Brown (2005)

The British Book of Spells and Charms: A Compilation of Traditional Folk Magic by Graham King (2016)

Magical Symbols and Alphabets: A Practitioner's Guide to Spells, Rites, and History by Sandra Kynes (2020)

Icelandic Folk Magic: Witchcraft of the North by Albert Björn (2024)

SIGILS

The Book of Pleasure: (Self-Love) The Psychology of Ecstasy by Austin Osman Spare (2005)

Sigil Craft: Your Guide to Creating, Using, and Recognizing Magickal Symbols by Lia Taylor (2023)

Index of Symbols

Acorn 99	Ailm 35	Air 59	Aka 79	Algiz 37	Alpha 99	Amphitrite 97	Ansuz 91
Apple 63	Apple Cross Section 81	Aquarius 45	Aries 97	Arrow 103	Astraea 89	Auseklis Cross 37	Austra's Koks 103
Awen 45	Bee 107	Beith 75	Bell 121	Beltane 75	Berkana/ Bjarkaa 75	Bird 27	Bow and Arrow 39
Bowen Knot 111	Brigid's Cross 71	Brýnslustafir 31	Bull 31	Butterfly Mark 73	Calc 59	Cancer 31	Capricorn 115
Cauldron 101	Ceirt 41	Cēn 77	Ceres 81	Chalice 97	Claddagh Ring 39	Coll 109	Columba 93
Concentric Circles 77	Corn Dolly 79	Crescent and Arrow 83	Cross of the Moon 43	Crow 55	Dagaz 33	Dair 45	Daisy 29
Daisy Wheel 69	Delta 97	Double Spiral 115	Draumstafir 51	Draumstafur 57	Eadhadh 43	Ear 61	Earth (Alchemical) 73

Earth (Astronomical) 101	Ehwaz 31	Eihwaz 51	Eirene 49	Emancholl 47	Eunomia 75	Fearn 47	Fehu 89
Feingur 99	Fire 63	First Quarter Moon 105	Fish 47	Flora 73	Fortuna 107	Four-Leaf Clover 117	Fractal 41
Full Moon 91	Gar 117	Gebô 111	Gemini 91	Gêr 103	Gold 105	Gort 99	Gratitude 81
Greek Key 111	Gungnir 35	Haglaz 87	Hawthorn 75	Hebe 99	Hercules 107	Herðslustafir 89	Hexahedron 119
Holly 69	Honey 119	Horned God 75	Horse Chestnut 59	Horse 89	Horseshoe 101	Huginn and Muninn 115	Hygeia 65
Hypnos 55	Icelandic staves for the New Moon 87	for public services 117	for relaxation 59	for sexual energy 63	Icosahedron 51	Ifín/Pin 71	Imbolc 71
Infinity 39	Ing (Elder Futhark) 55	Ing (Anglo-Frisian) 79	Iodhadh 65	Īor 71	Iris 29	Iron 43	Iron Nail 93
Isa 69	Ivy Leaf 111	Jāṇi 77	Jarylo 49	Jera/Jara 81	Juno 111	Jupiter 65	Kaupaloki 119
Kenaz 35	Key 115	Koliada 69	Krupitis 105	Kupala 77	Laguz 45	Lammas 79	Lásabrjótur 35

Lead 105	Leaping Hare 73	Leo 27	Lepus 63	Libra 93	Lily of the Valley 103	Litha 77	Luckenbooth 99
Luis 27	Lukkustafir 91	Lupus Mettalorum 109	Lyra 55	Mabon 81	Mannaz 41	Mara 73	Māra's Cross 101
Marian Mark 29	Mars 61	Mēness 91	Mercury 115	Mesh 83	Metenis 71	Metis 31	Modig 27
Mokosh 45	Monas Hieroglyphica 49	Moon 55	Moon Gazing Hare 91	Morok 43	Muin 39	Naed 51	Naudiz 47
Nazar 37	Neptune 57	New Moon 87	nGéadal 33	Nion 49	Oak 83	Óir 77	Onn 121
Ostara 73	Othala 101	Ouroboros 69	Owl 35	Pallas 43	Pax Cultura 121	Pentacle 33	Pentagram 29
Perperuna 47	Persephone 83	Perseus 119	Perthro 107	Pictish Serpent and Spear 65	Pictish Sun Disk 71	Pisces 121	Polaris 87
Psyche 59	Radegast 119	Raido 97	Rowan 117	Ruis 87	Sagittarius 109	Sail 51	Sailor's Knot 109
Salacia 59	Salt 83	Samhain 83	Sator Square 109	Saule 49	Saulė 65	Scorpio 105	Scythe 79

Semargl 41	Sheela Na Gig 63	Sheep 79	Sigma 107	Silver 57	Snake 37	Sol 27	Solomon's Knot 119
Stan 41	Straif 93	Sulfur 57	Sun 33	Sunflower 33	Svefnthorn 55	Sycamore 57	Taranis 43
Tau 61	Taurus 63	Tetrahedron 27	Third Quarter Moon 117	Thurisaz 93	Tinne 117	Tiwaz 105	Triglav 103
Triquetra 103	Triskele 51	Troll Cross 49	Tyr 89	Uath 37	Uilleann 29	Unicursal Hexagram 57	Upsilon 109
Úr 97	Uranus 107	Uruz 61	Veles 45	Venus 39	Vessel 33	Vesta 101	Victoria 31
Virgo 47	Waning Crescent Moon 93	Waning Gibbous Moon 65	Water 87	Waxing Crescent Moon 89	Waxing Gibbous Moon 35	Wheat 41	Widdershins 37
Wine 81	Wishbone 39	Witch's Knot 121	Wool 121	Wunjo 29	Yarilo 49	Yr 115	Yule 69
Zeus 61	Živa 111	Þjófastafur 61					

Index of Symbols ♦♦♦ 139

Acknowledgments

This book is dedicated to Adam: my partner, my best friend, and my editor who makes sure I don't include too many commas. Thank you for supporting me through all my endeavours – from writing my Master's thesis to travelling to Southern Albania for fieldwork and now this book – and for always believing in me (even when I didn't). You are my biggest fan and I couldn't have done it without you.

This book is also dedicated to our daughter, Imogen. Our wonderful girl who collects stones for me on walks, adores the moon, and steals my Tarot cards. You are my greatest joy.

Thank you to my Mum and Dad, and our regular trips to museums, libraries, and historic places, for developing my love for history. I firmly believe my Mum's crystal egg collection and her knowledge of folk traditions – crushing egg shells, sticking pins in cushions to find a lost item, and lavender being the answer to everything – were my gateway to Witchcraft. Thank you to my sisters Kat and Alison for their endless support while I wrote this book, especially the memes.

To my friends who have always raised me up and celebrated my strengths: you are all amazing. I am so grateful to have such wonderful humans in my life.

A special thanks to the wonderful Instagram community I am so lucky to be a part of. I have found lifelong friends in the witchy family and I am so grateful to every single one of you for the support and belief you have in me and my work. Finally, a huge thank you to Sophie Lazar at Leaping Hare Press who believed wholeheartedly in my work and supported me through writing this book. Thank you for making my dream of becoming a published author come true.

About the Author

Amy Donnelly is an author, folklore enthusiast and archaeologist from Essex, England. She currently lives in Bristol with her partner, daughter, and hamster.

Growing up with a family who loves history, she studied Archaeology BA at the University of Bristol and later completed a Postgraduate degree in Archaeology and Anthropology, focusing on the perception of cultural heritage in post-communist rural southern Albania.

Amy began her Instagram account, @folkwitch_, during the Covid pandemic as a way of connecting with like-minded pagans throughout lockdown. She enjoys researching the origins of folk traditions and applying her findings to her own magical practice.

Amy has a special interest in the material remains of British folklore and its lasting impact on contemporary society and culture. She has written several articles for pagan magazines regarding folk traditions and archaeological evidence of their use. *Practical Symbols* is her first book.

About the Illustrator

Viki Lester of FORENSICS & FLOWERS is an illustrator from London. Her work inspires people to feel magical, and features positivity with a dark botanical twist.

Index

A
acorn 99
Ailm 35
air 59
Aka 79
Algiz 12, 37
Alpha 99
Amphitrite 97
Anglo-Frisian 17
Ansuz 91
apple 63
apple cross section 81
Aquarius 45
Aries 97
arrow 103
Astraea 89
Auseklis Cross 37
Austra's Koks 103
Awen 45

B
babies, symbols for new 98–9
bee 107
Beith 75
bell 121
Beltane 74–5
Berkana 75
bird 27
birthdays, symbols for 102–3
Bjarka 75
Bow and Arrow 39
Bowen Knot 111
Brigid's Cross 71
Brýnslustafir 31
bull 31
Butterfly Mark 73

C
Calc 59
Cancer 31
Capricorn 115
careers 112–21
symbols for career goals 104–5
cauldron 101
Ceirt 41
Cēn 77
Ceres 81
chalice 97
change, symbols for big 96–7
Claddagh Ring 39
Coll 109
Columba 93
Concentric Circles 77
confidence, symbols for 26–7
context 8
corn dolly 79
courage, symbols for 42–3
creativity
symbols for creatives 120–1
symbols for creativity 44–5
Crescent and Arrow 83
Cross of the Moon 43
crow 55
customer services, symbols for 118–19

D
Dagaz 10, 33
Dair 45
daisy 29
Daisy Wheel 69
Delta 97
Double Spiral 115
Draumstafir 51
Draumstafur 57
dreams, symbols for good 56–7

E
Eadhadh 43
Ear 61
Earth (Alchemical) 73
Earth (Astronomical) 101
Ehwaz 31
Eihwaz 51
Eirene 49
Elder Futhark 16
Emancholl 47
energy
symbols for energy 60–1
symbols for sexual energy 62–3
Eunomia 75

F
Fearn 47
Fehu 89
Feingur 99
fire 63
First Quarter Moon 105
fish 47
Flora 73
focus, symbols for 34–5
Fortuna 107
four-leaf clover 117
fractal 41
Full Moon, symbols for the 90–1

G
Gar 117
Gebô 111
Gemini 91
Gēr 103
gold 105
Gort 99
graduation, symbols for 106–7
gratitude 40–1, 81
Greek Key 111
grief, symbols for 50–1
Gungnir 35

H
Haglaz 87
hawthorn 75
Hebe 99
Hercules 107

Herðslustafir 89
hexahedron 119
holly 69
homes, symbols for new 100–1
honey 119
Horned God 75
horse chestnut 59
horse 89
horseshoe 101
Huginn and Munnin 115
Hygeia 65
Hypnos 55

I
Icelandic staves 19
 for the New Moon 87
 for public services 117
 for relaxation 59
 for sexual energy 63
icosahedron 51
Ifín 71
Imbolc 70–1
infinity symbols 39
Ing (Anglo-Frisian) 79
Ing (Elder Futhark) 55
intuition 13
Iodhadh 65
Íor 71
Iris 29
iron 43
 iron nail 93
Isa 69
ivy leaf 111

J
Jāi 77
Jara 81
Jarylo 49
Jera 81
journeys, symbols for 108–9
joy, symbols for 28–9
Juno 111
Jupiter 65

K
Kaupaloki 119
Kenaz 35
key 115
Koliada 69

Krupitis 105
Kupala 77

L
Laguz 45
Lammas 78–9
Lásabrjótur 35
lead 105
Leaping Hare 73
Leo 27
Lepus 63
Libra 93
lily of the valley 103
Linear B 21
Litha 76–7
loss, symbols for 50–1
love, symbols for 38–9
Luckenbooths 99
Luis 27
Lukkustafir 91
Lupus Mettalorum 109
Lyra 55

M
Mabon 10, 80–1
magic squares, using 128–30
Mannaz 41
Mara 73
Māra's Cross 101
Marian Marks 29
marriage, symbols for 110–11
Mars 61
Mēness 91
Mercury 115
mesh 83
Metenis 71
Metis 31
Modig 27
Mokosh 45
Monas Hieroglyphica 49
The Moon 55, 84–93
 First Quarter Moon 105
 Full Moon 90–1
 Moon Gazing Hare 91
 New Moon 87
 Third Quarter Moon 117
 Waning Gibbous Moon 65
 Waning Moon 92–3
 Waxing Crescent 89

 Waxing Gibbous Moon 35
 Waxing Moon 88–9
Morok 43
motivation, symbols for 46–7
Muin 39

N
Naed 51
Naudiz 47
Nazar 37
Neptune 57
New Moon 87
nGéadal 33
Nion 49

O
oak 83
Ogham 18
Óir 77
Onn 121
Ostara 72–3
Othala 101
Ouroboros 69
owl 35

P
Pallas 43
Pax Cultura 121
peace, symbols for 48–9
pentacle 33
pentagram 29
Perperuna 47
Persephone 83
Perseus 119
personal wellness, symbols for 64–5
Perthro 107
physical wellness, symbols for 52–65
Pictish 20
 Pictish Serpent and Spear 65
 Pictish Sun Disk 71
Pin 71
Pisces 121
Polaris 87
positivity, symbols for 32–3
productivity, symbols for 30–1
protection, symbols for 36–7

Psyche 59
public services, symbols for 116–17

R
Radegast 119
Raido 97
relaxation, symbols for 58–9
research 12–13
rowan 117
Ruis 87

S
Sabbats, symbols for 66–83
Sagittarius 109
Sail 51
Saille 51
Sailor's Knot 109
Salacia 59
salt 83
Samhain 82–3
Sator Square 109
Saule 49
Saulė 65
Scorpio 105
scythe 79
Semargl 41
sexual energy, symbols for 62–3
Sheela Na Gig 63
sheep 79
sigils
 crafting your own 125
 history of 124
 in the modern era 124
 practical 122–31
 using a magic square 128–30
 using a sigil wheel 126–7
Sigma 107
silver 57
sleep
 symbols for better sleep 54–5
 symbols for good dreams 56–7
snake 37
Sol 27
Solomon's Knot 119

Spare, Austin Osman 124, 125
special occasions, symbols for 94–111
Stan 41
Straif 93
sulfur 57
the Sun 33
sunflower 33
Svefnthorn 55
sycamore 57
symbols
 changing nature of 10–11
 choosing 12–14
 how to use 14
 symbol use in Witchcraft 9

T
Taranis 43
Tau 61
Taurus 63
technology, symbols for 114–15
tetrahedron 27
Third quarter Moon 117
Thurisaz 93
Tinne 117
Tiwaz 105
Triglav 103
Triquetra 103
Triskele 51
Troll Cross 49
Tyr 89

U
Uath 37
Uilleann 29
Unicursal Hexagram 57
Upsilon 109
Úr 97
Uranus 107
Uruz 61

V
Veles 45
Venus 39
vessel 33
Vesta 101
Victoria 31
Virgo 47

W
Waning Moon, symbols for 92–3
 Waning Crescent Moon 93
 Waning Gibbous Moon 65
water 87
Waxing Moon, symbols for the 88–9
 Waxing Crescent Moon 89
 Waxing Gibbous Moon 35
wellness
 symbols for 24–51
 symbols for personal wellness 64–5
 symbols for physical wellness 52–65
wheat 41
Widdershins 37
wine 81
wishbone 39
Witchcraft, symbol use in 9
Witch's Knot 121
wool 121
Wunjo 29

Y
Yarilo 49
Yr 115
Yule 68–9

Z
Zeus 61
Živa 111

Þófastafur 61

Index ♦♦♦ 143

Quarto

First published in 2024 by Leaping Hare Press,
an imprint of The Quarto Group.
One Triptych Place
London, SE1 9SH,
United Kingdom
T (0)20 7700 6700
www.Quarto.com

Design and Illustrations Copyright © 2024 Quarto
Text Copyright © 2024 Amy Donnelly

Amy Donnelly has asserted her moral right to be identified as the Author of this Work in accordance with the Copyright Designs and Patents Act 1988.

All rights reserved. No part of this book may be reproduced or utilised in any form or by any means, electronic or mechanical, including photocopying, recording or by any information storage and retrieval system, without permission in writing from Leaping Hare Press.

Every effort has been made to trace the copyright holders of material quoted in this book. If application is made in writing to the publisher, any omissions will be included in future editions.

A catalogue record for this book is available from the British Library.

ISBN 978-0-7112-9701-2
Ebook ISBN 978-0-7112-9702-9

10 9 8 7 6 5 4 3 2 1

Design by Nikki Ellis

Editorial Director: Monica Perdoni
Commissioning Editor: Sophie Lazar
Editor: Katerina Menhennet
Senior Designer: Renata Latipova
Production Controller: Rohana Yusof

Printed in China

MIX
Paper | Supporting responsible forestry
FSC® C016973

Also available from Leaping Hare Press:
Practical Crystals: Crystals for Holistic Wellbeing (2023)
And coming in 2025: *Practical Chakras*